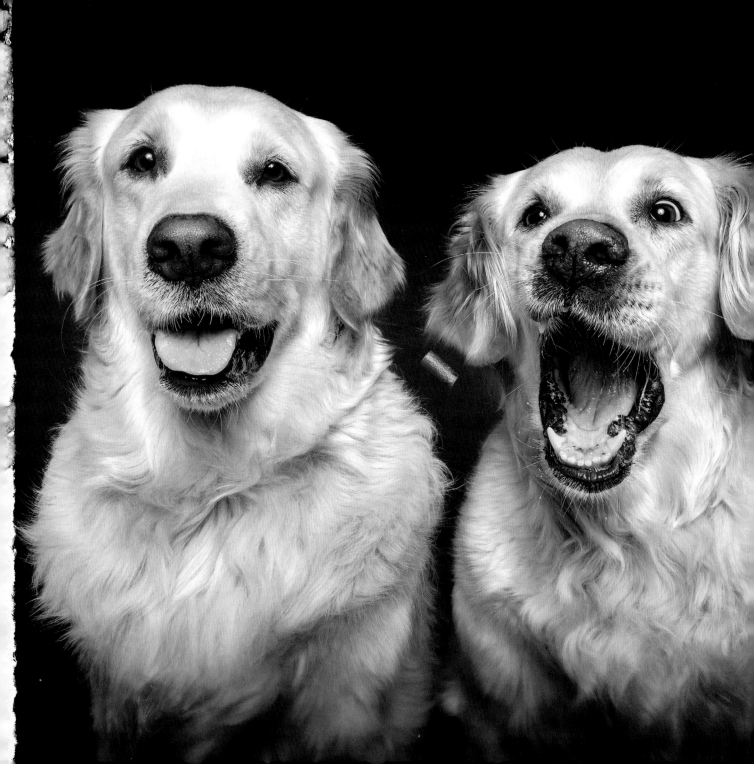

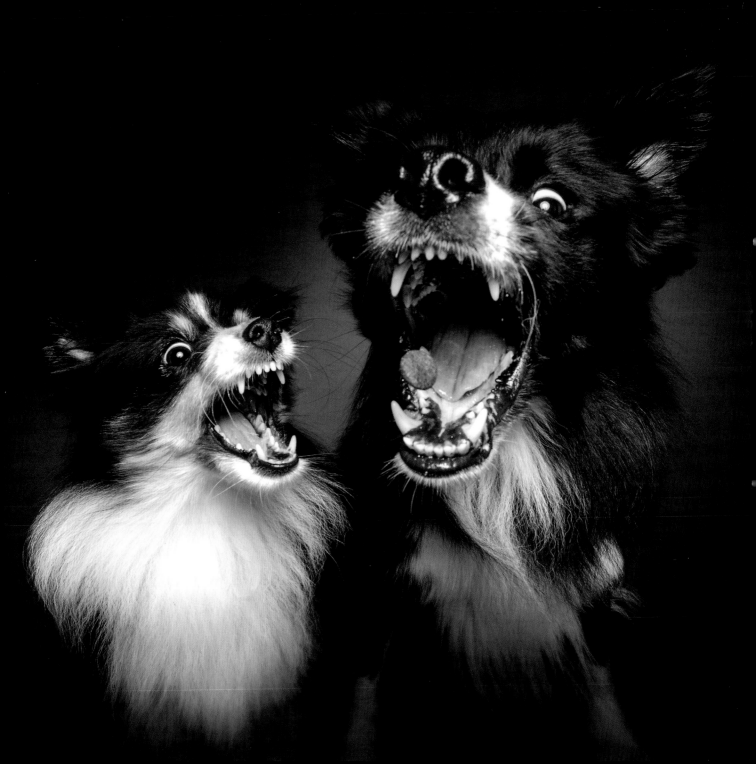

TREAT TOO!

TWO TAILS ARE BETTER THAN ONE

CHRISTIAN VIELER

BLACK DOG
& LEVENTHAL
PUBLISHERS
NEW YORK

Black Dog & Leventhal Publishers
Hachette Book Group
1290 Avenue of the Americas
New York, NY 10104

www.hachettebookgroup.com
www.blackdogandleventhal.com

First Edition: August 2021

Black Dog & Leventhal Publishers is an imprint of Perseus Books, LLC, a subsidiary of Hachette Book Group, Inc. The Black Dog & Leventhal Publishers name and logo are trademarks of Hachette Book Group, Inc.

The publisher is not responsible for websites (or their content) that are not owned by the publisher.

The Hachette Speakers Bureau provides a wide range of authors for speaking events. To find out more, go to www.HachetteSpeakersBureau.com or call (866) 376-6591.

Print book interior design by Katie Benezra

ISBNs: 978-0-7624-7238-3 (hardcover), 978-0-7624-7237-6 (ebook)

Printed in China

APS

10 9 8 7 6 5 4 3 2 1

I DEDICATE THIS BOOK TO MY FAMILY.

Thank you, Mom, for your neverending support.

Thank you, Linda & Tamml, Lotte, Anni, and Alfred,
who are always at my side. Cheers.

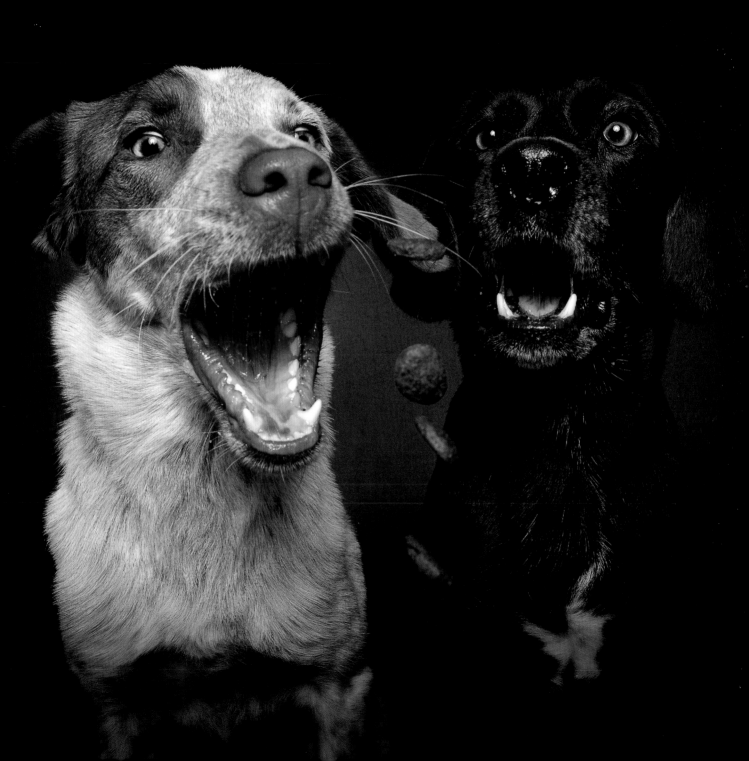

INTRODUCTION

Toward the end of 2015, an image agency approached me about my photographs, which, up to that point, had only been in photography forums like 500px. Just a few days later, my work was everywhere—including some of the most renowned newspapers in the world—and quickly went viral online. It was unbelievable. Within hours, an avalanche of social media developed, which quickly overran my entire life. What started as a living room hobby developed rapidly during perhaps the most exciting time of my life. There were television appearances, interviews, and an everyday life that I was suddenly able to dedicate entirely to dogs and photography. Plus, I published my first book, *Treat!*, which still makes me proud today.

Now you have *Treat Too!* in your hands and may be wondering whether to buy the book or not. With all my heart I can only say, "Yes—do it." I am not saying this because you should finance my dream car for me or convince my publisher to sign up *Treat Three!* Because, really, what's better than one dog? How about two or even three? All of the photographs in this book show two or three dogs snapping for that much-sought-after treat. Besides the pure joy, anticipation, and sometimes concern of a single dog vying for a tasty morsel, there is now an added level of competition. You can almost see exclamations like, "Hey, what are you doing?" or, "But no I first!" or, "Attention, clear the way!" on the pups' faces.

Just like *Treat!*, *Treat Too!* simply warms the heart. I've had such a wonderful time photographing these special dogs and hope that they add a similar joy to your lives.

Yours,
Christian Vieler

Note: All dog pairs have been carefully selected. The depicted animals often live in the same household or have known each other for many years. Please do not try to take similar pictures with unknown dogs.

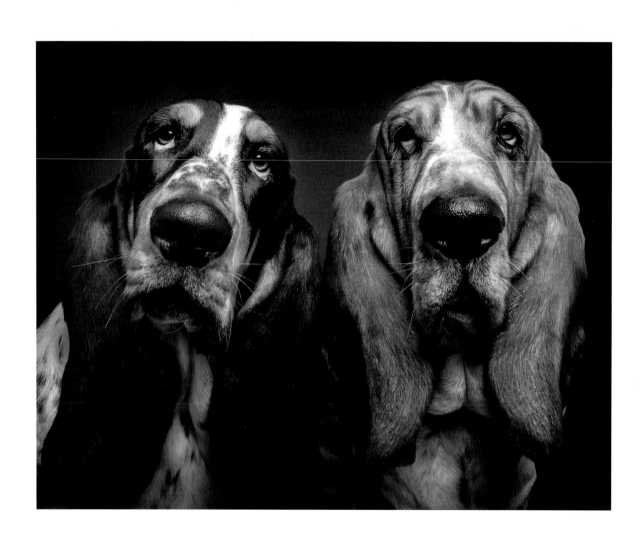

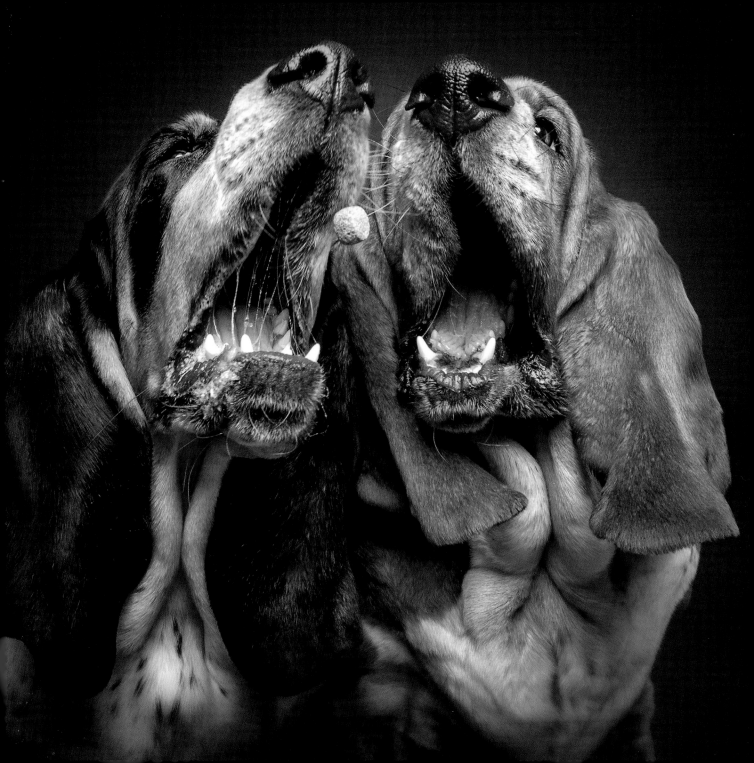

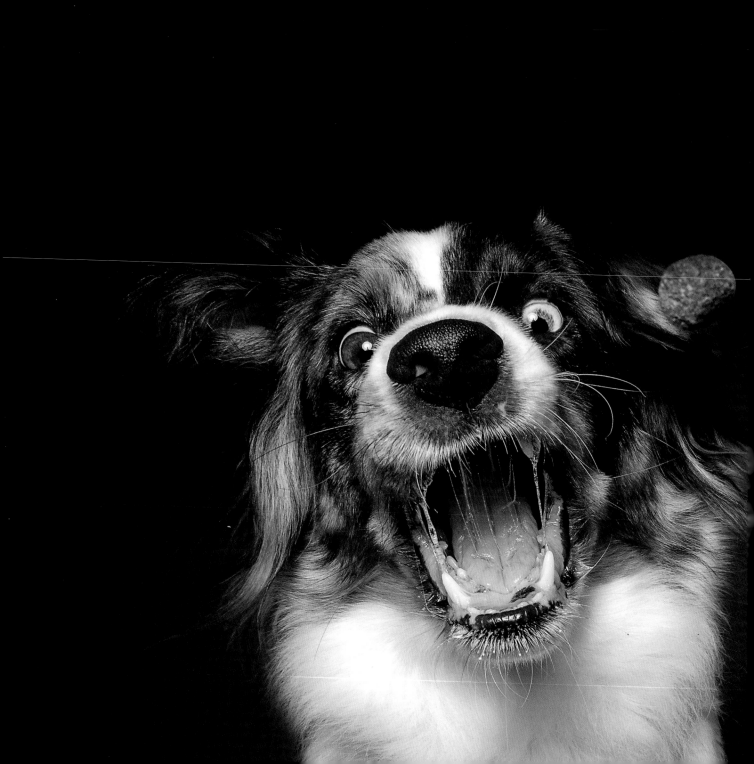

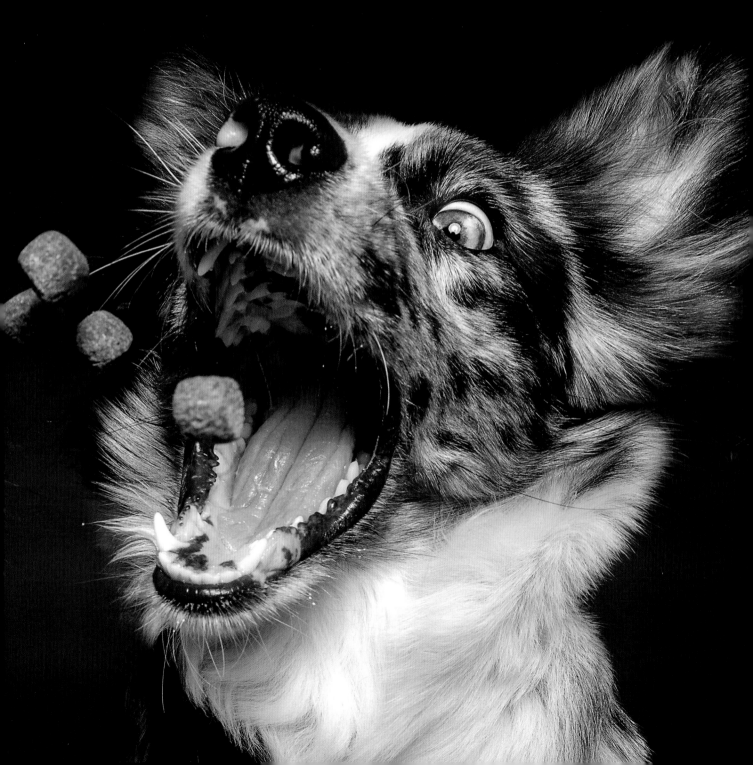

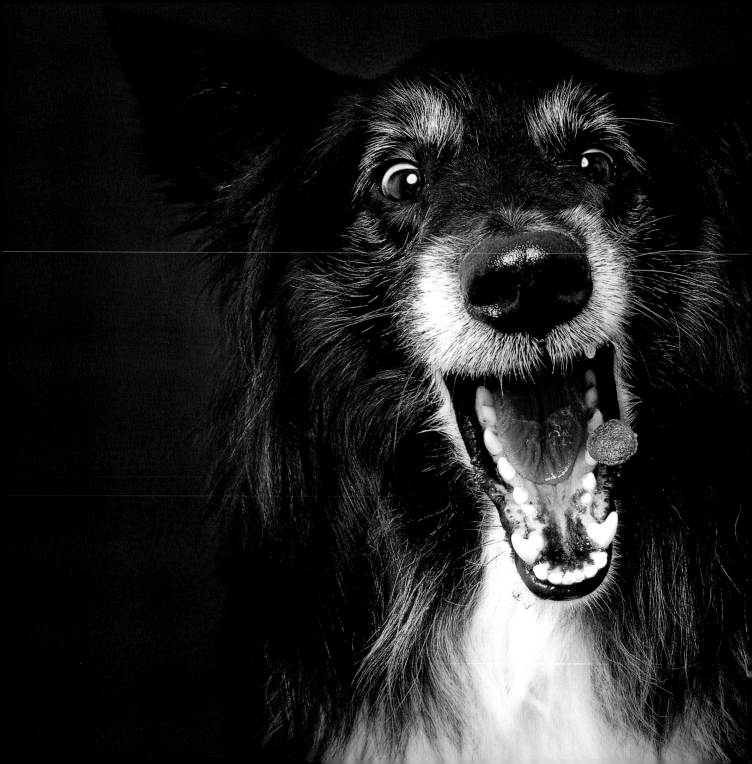

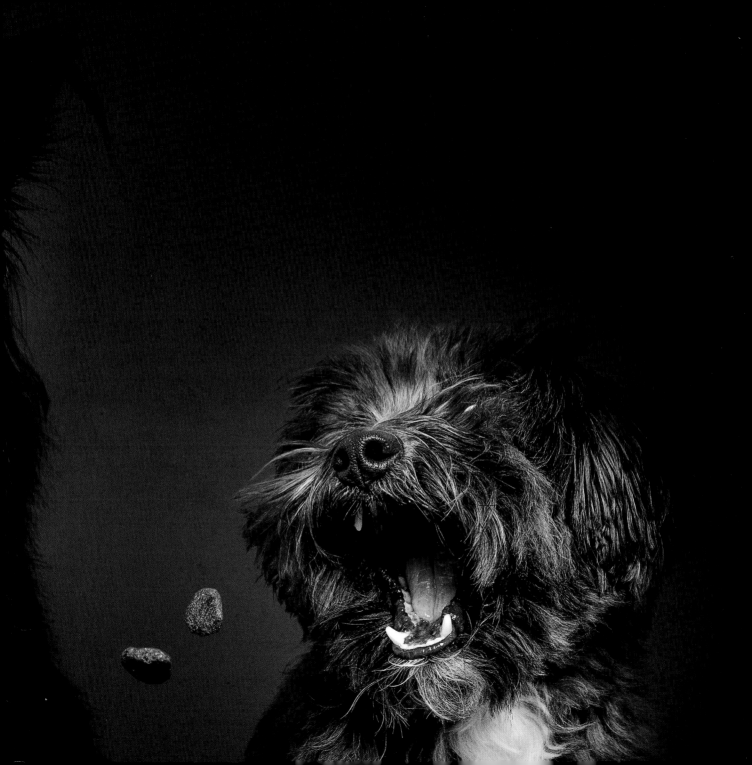

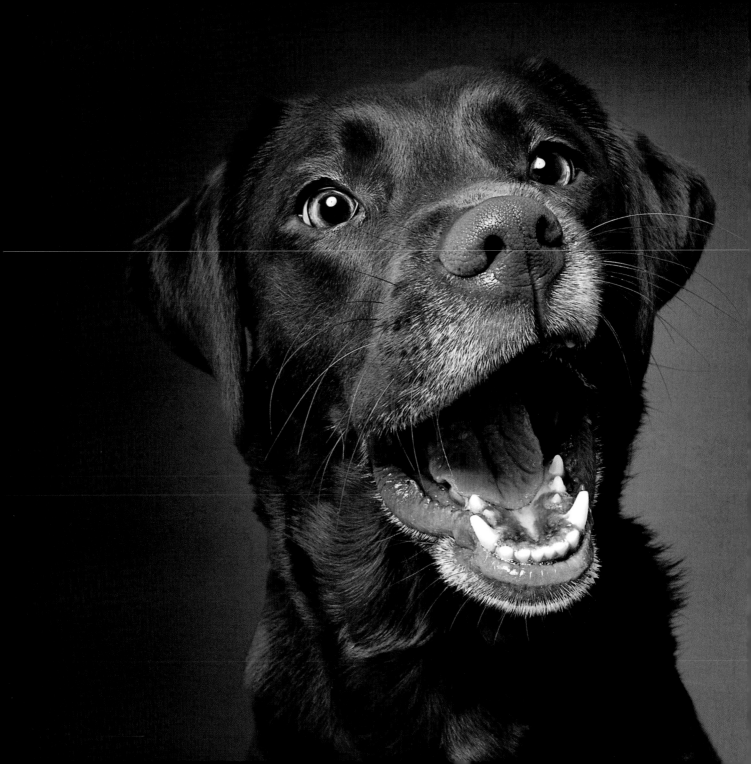

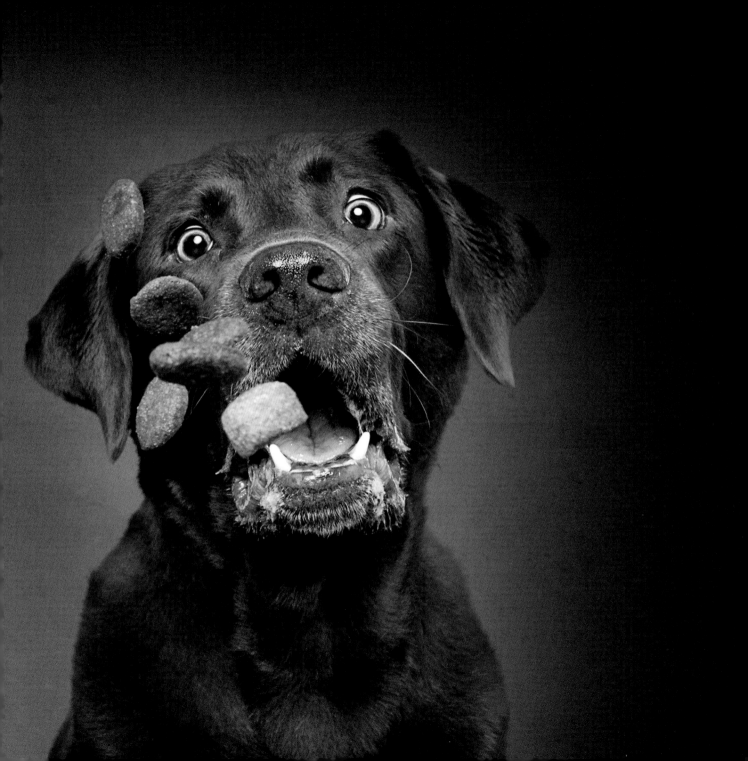

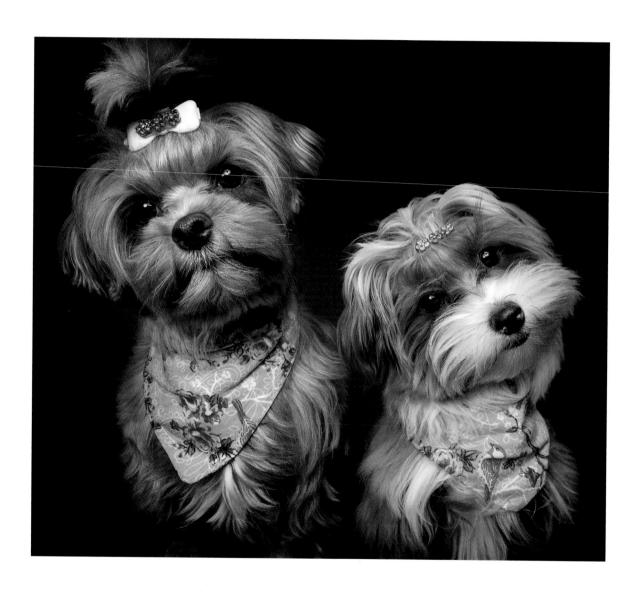

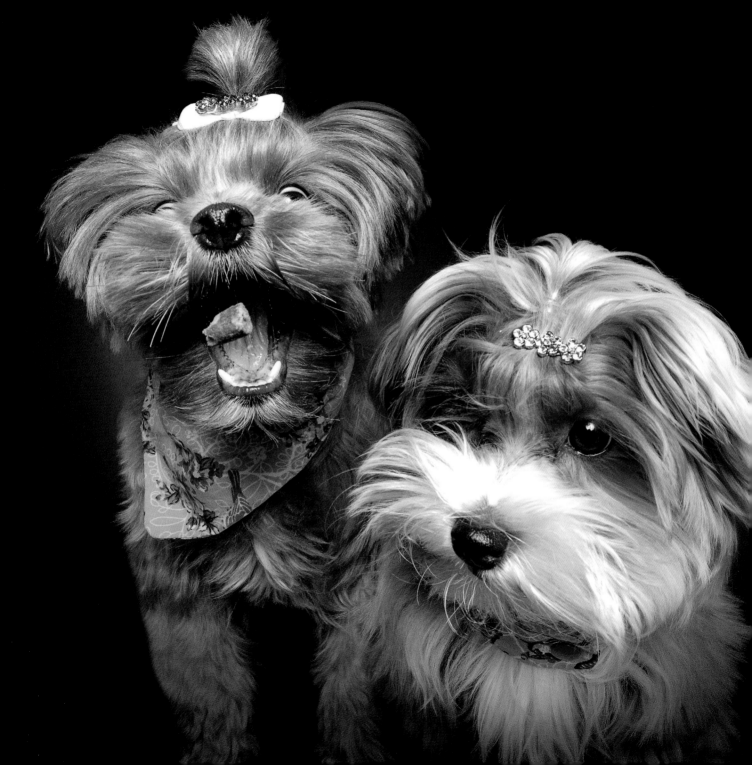

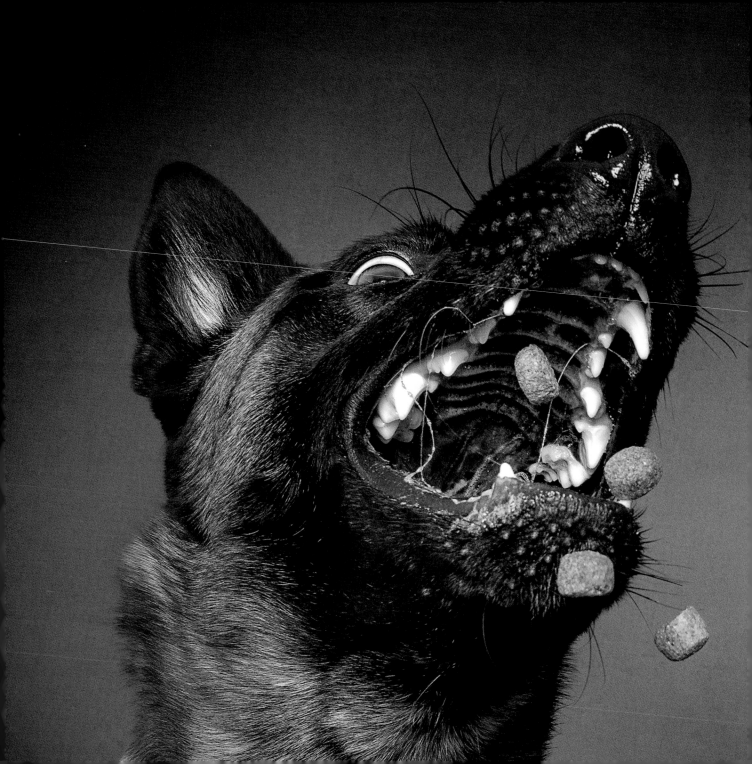

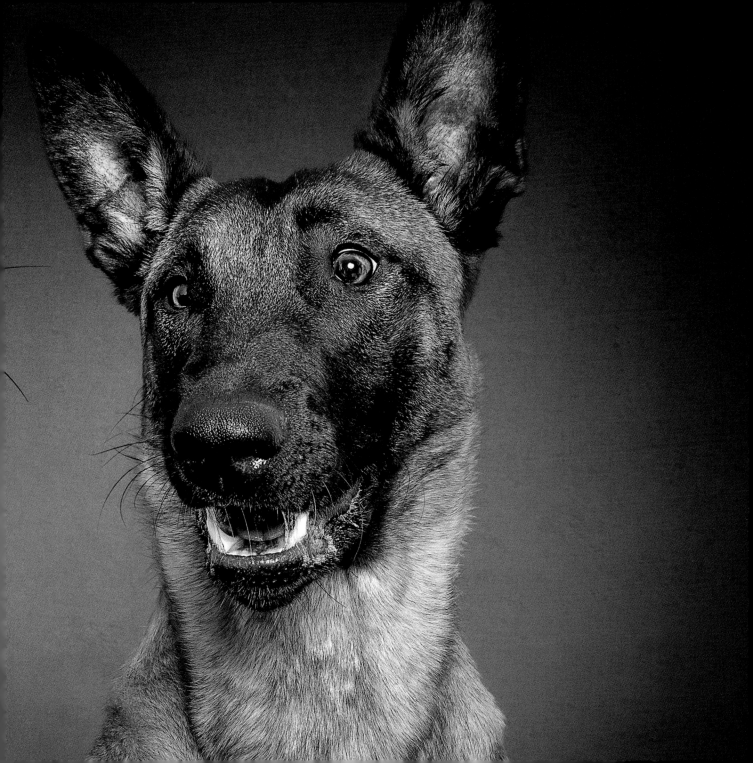

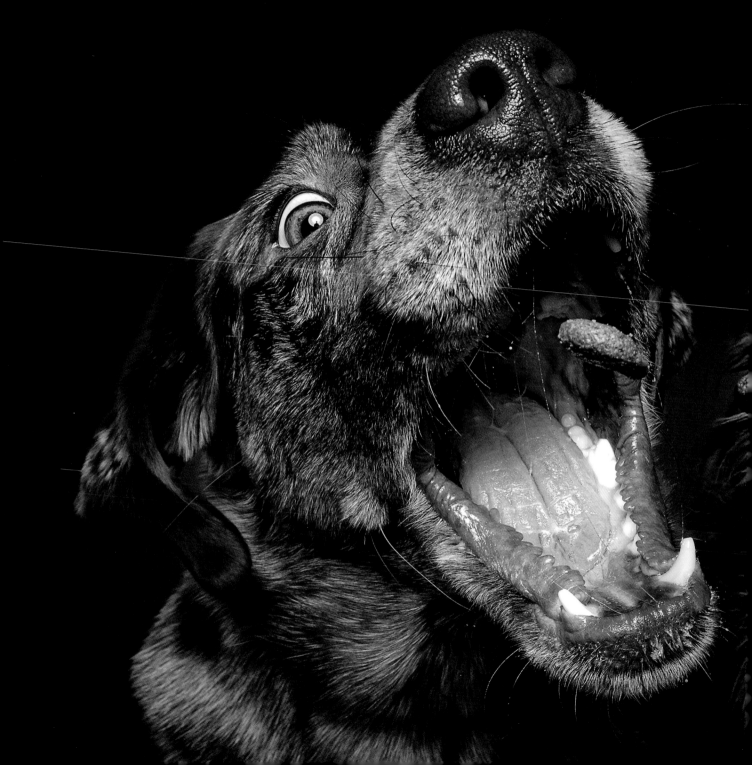

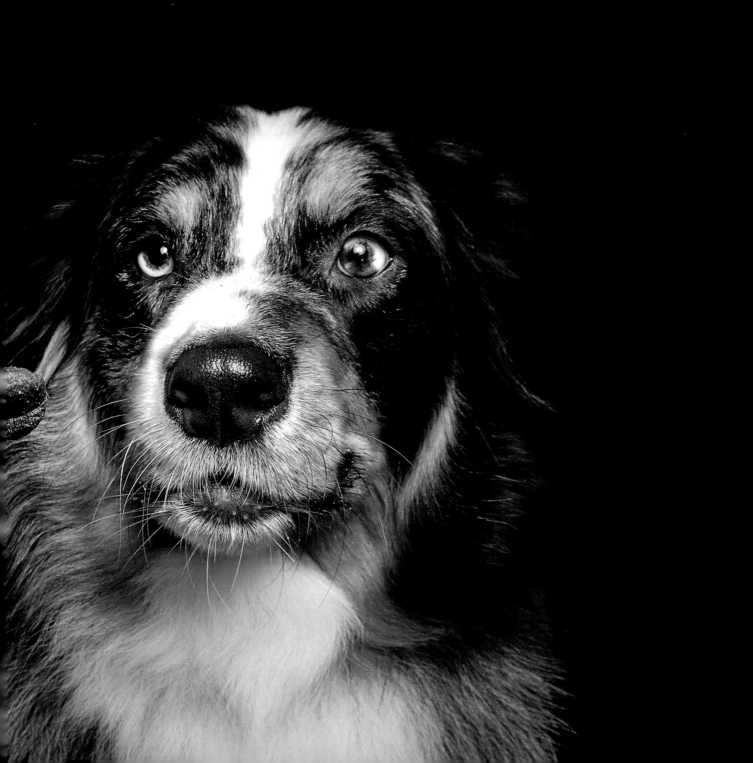

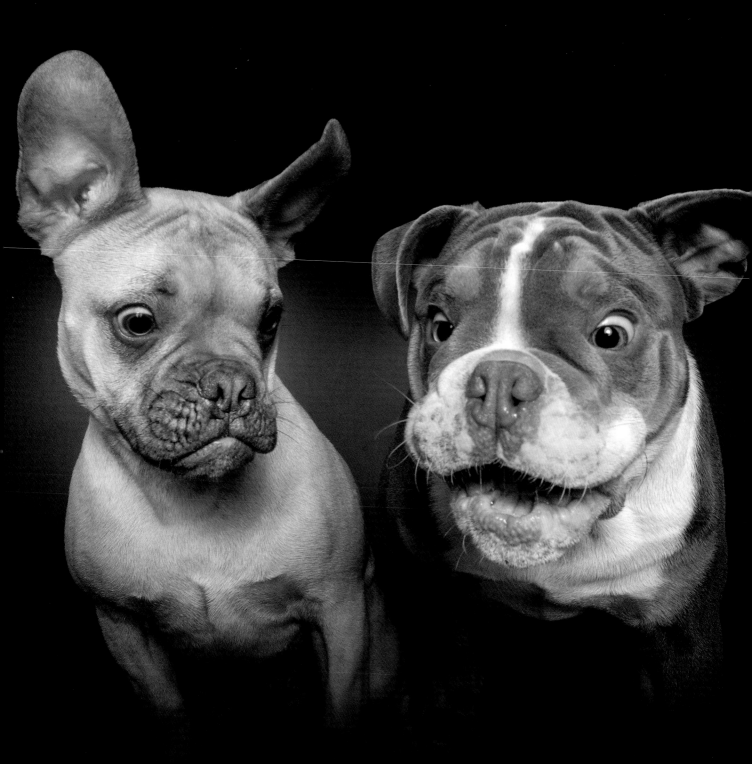

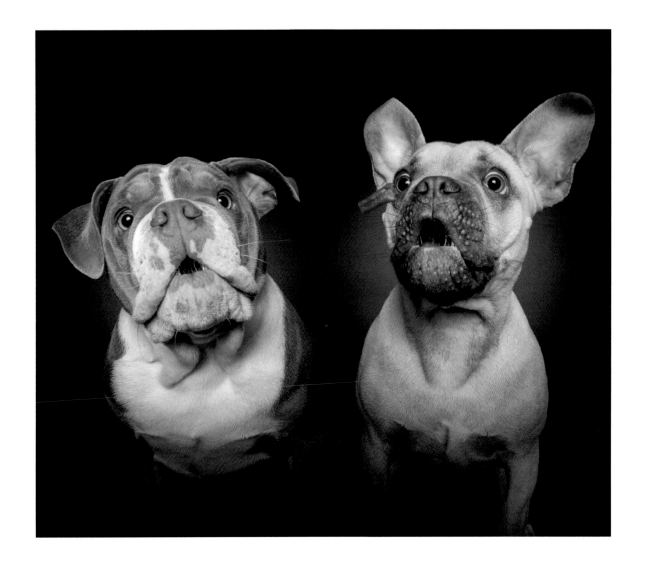

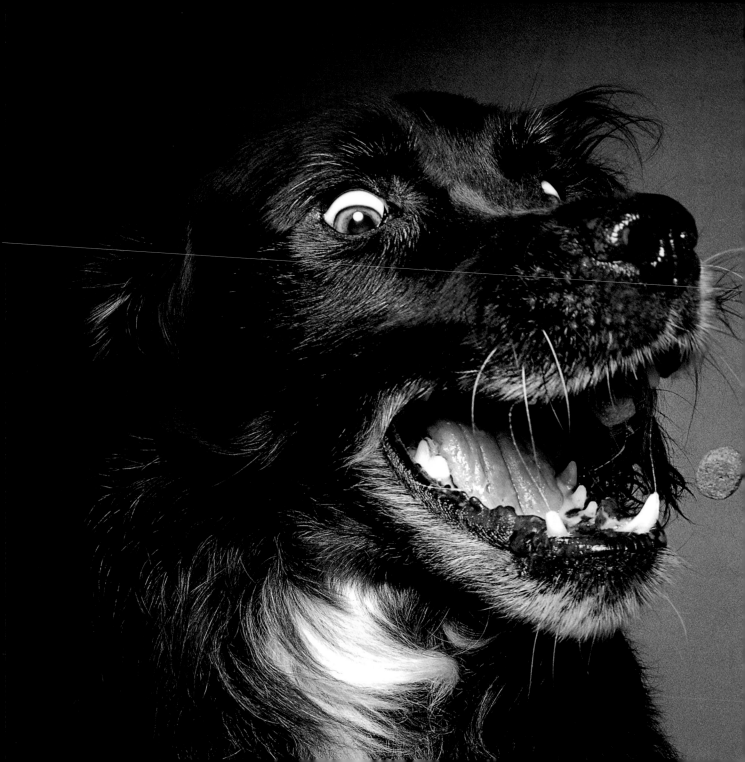

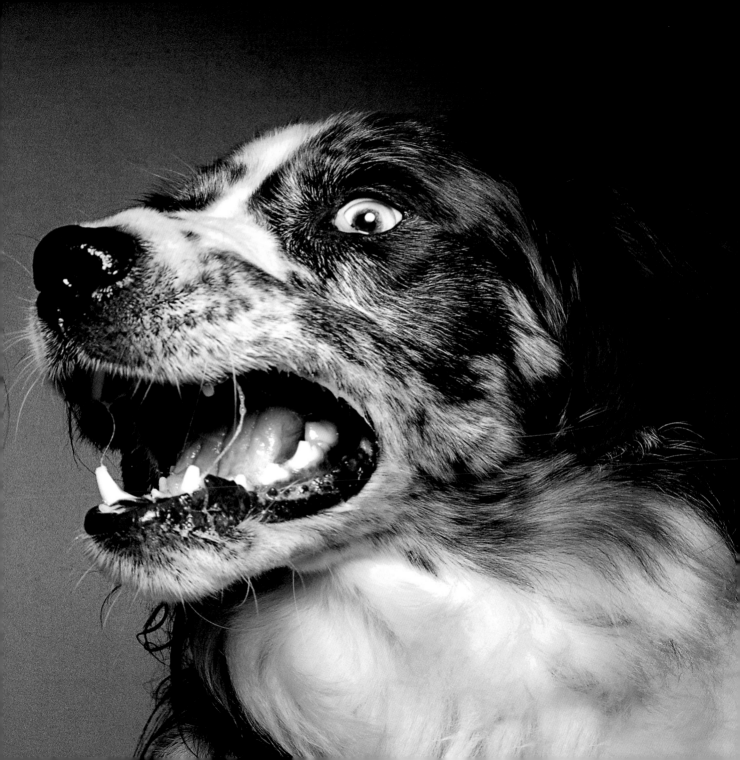

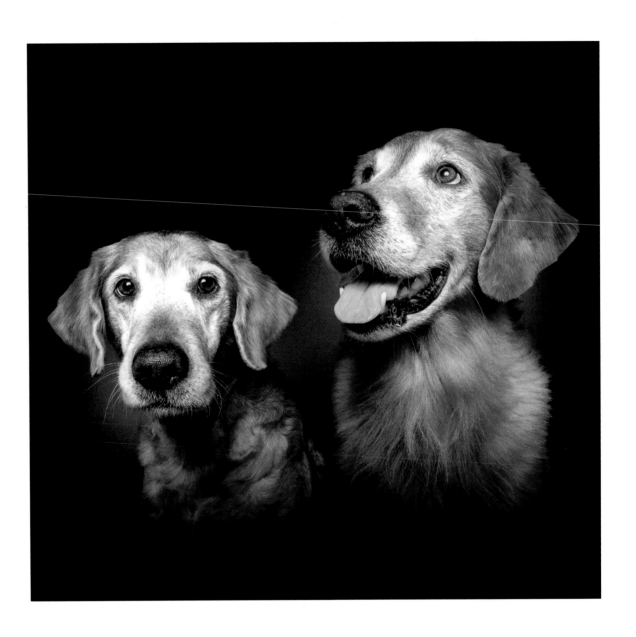

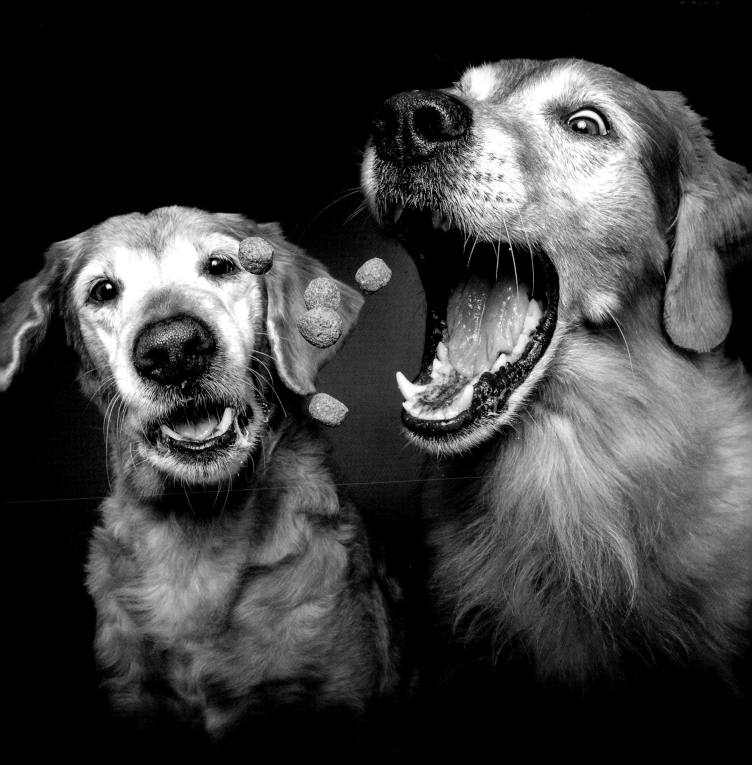

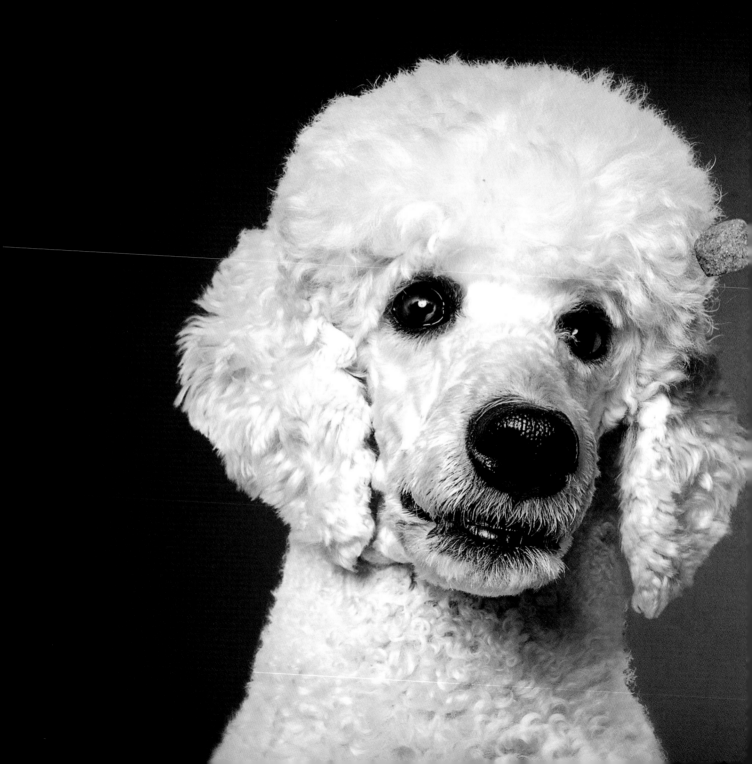

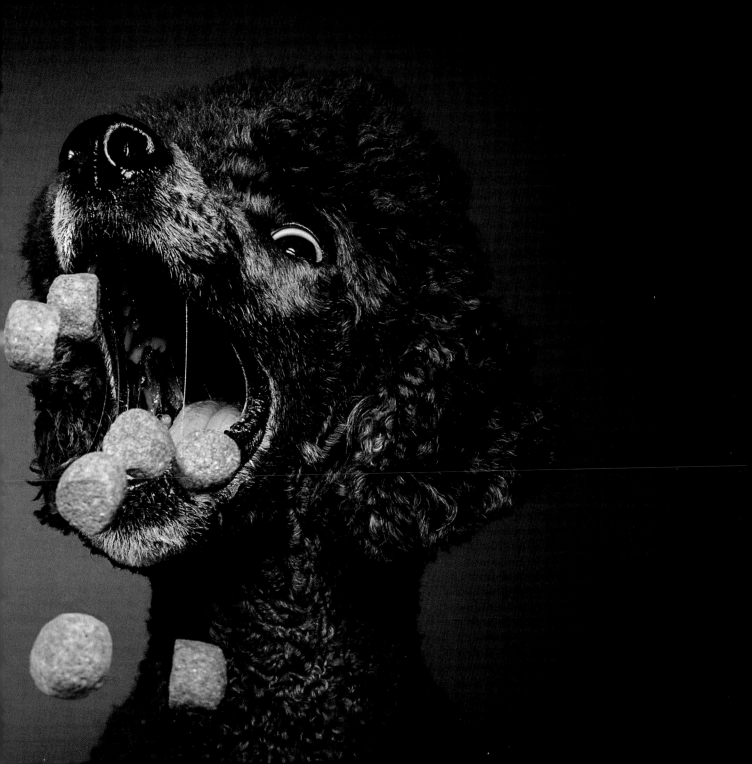

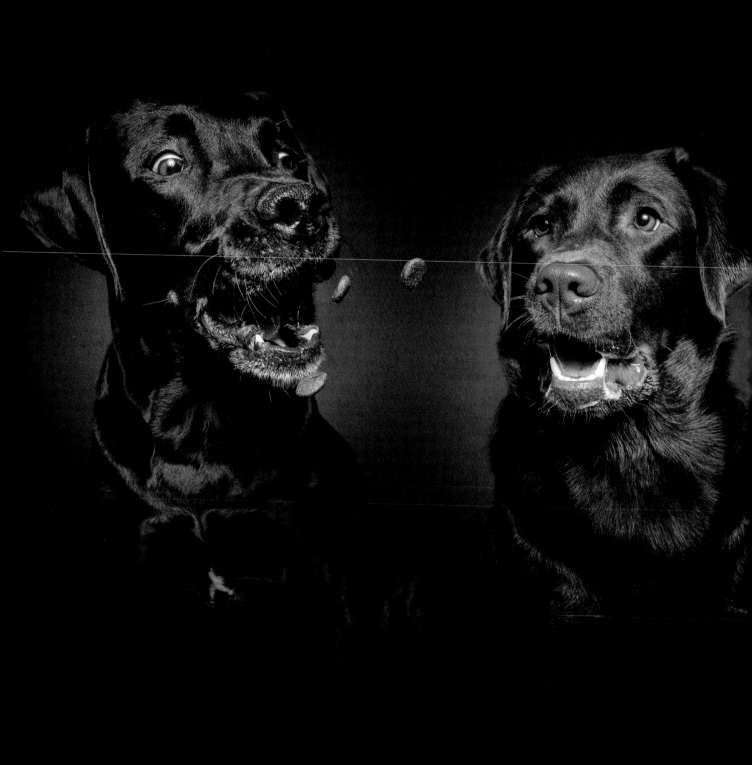

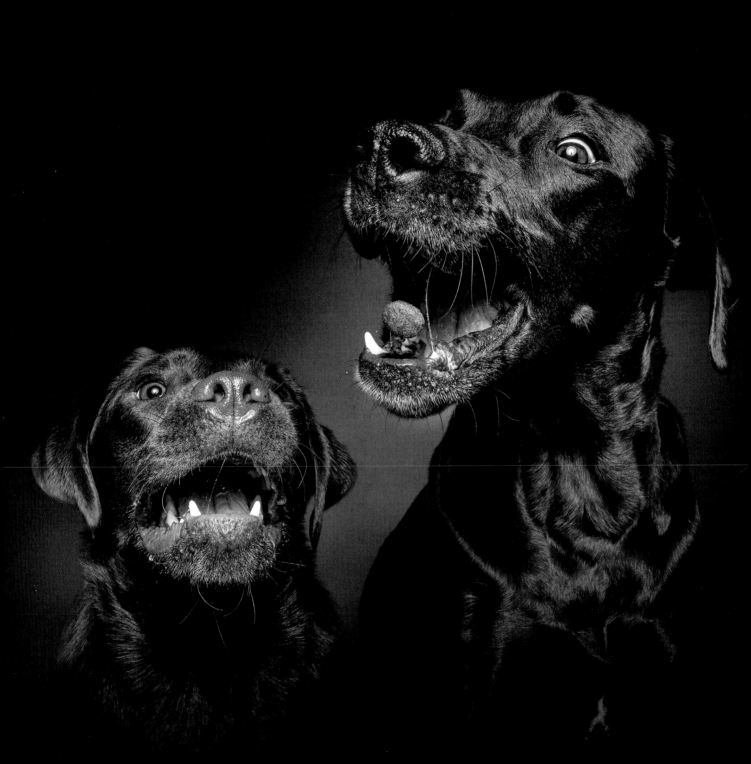

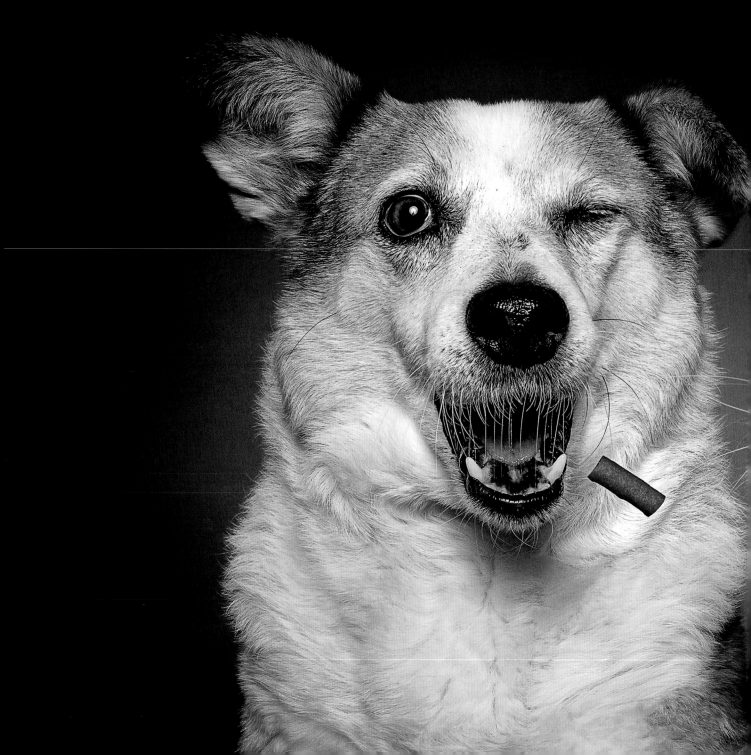

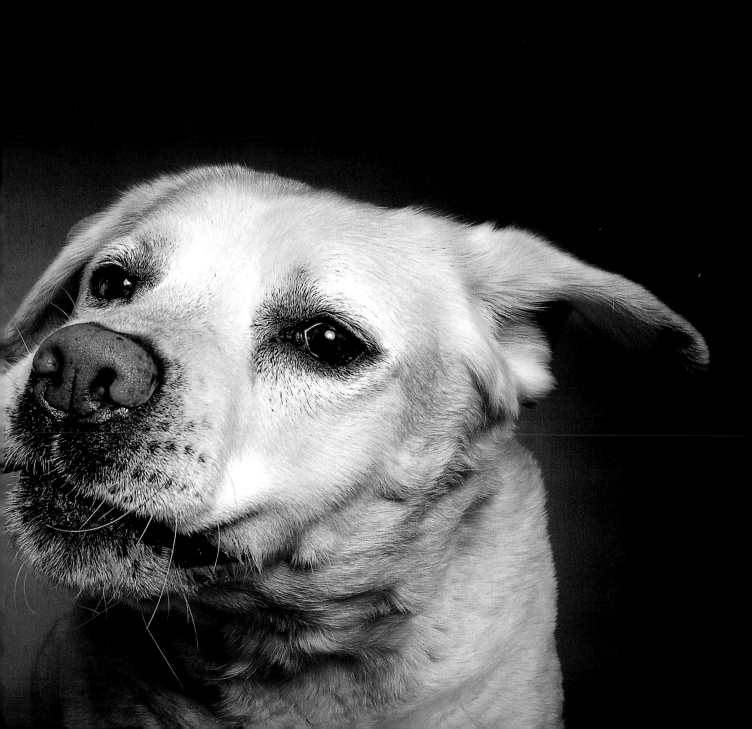

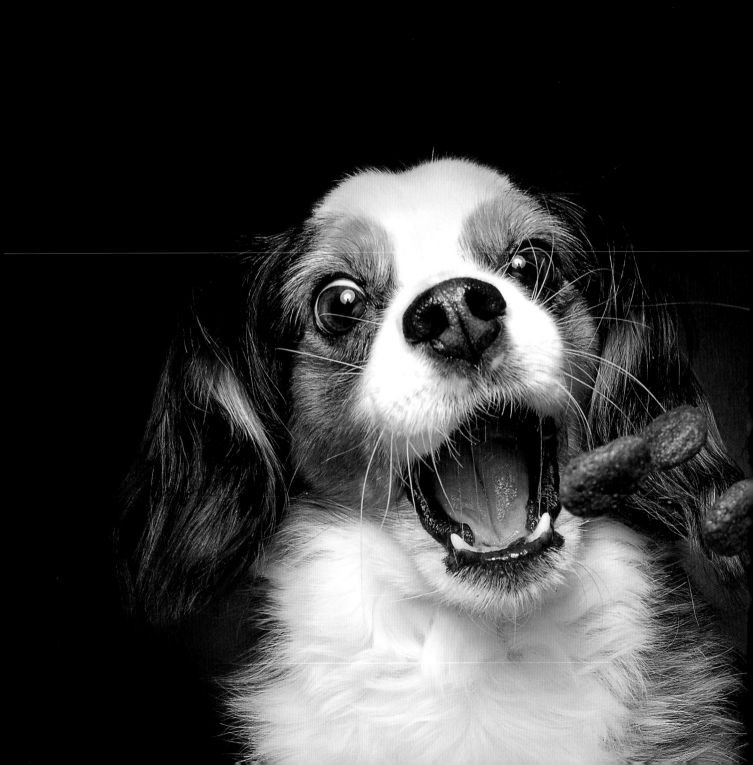

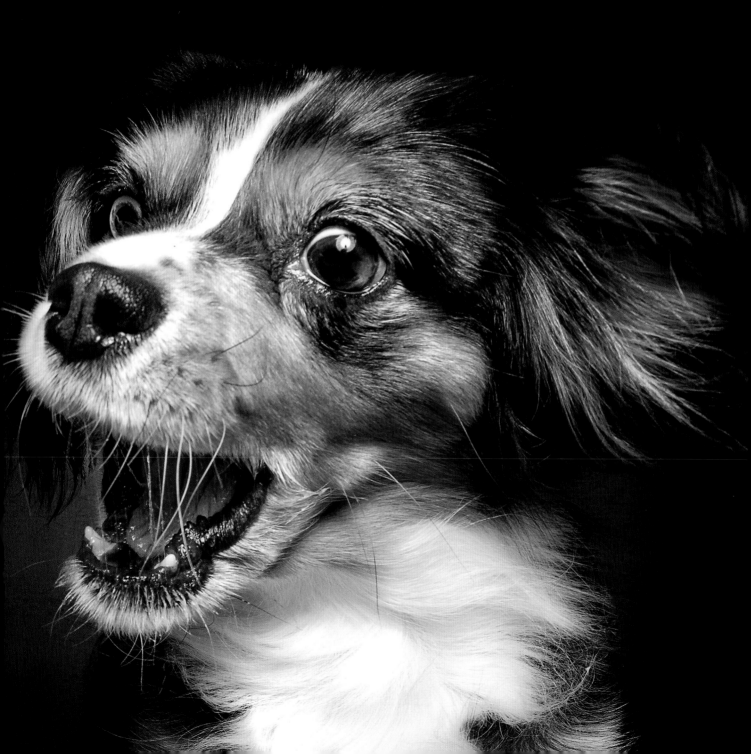

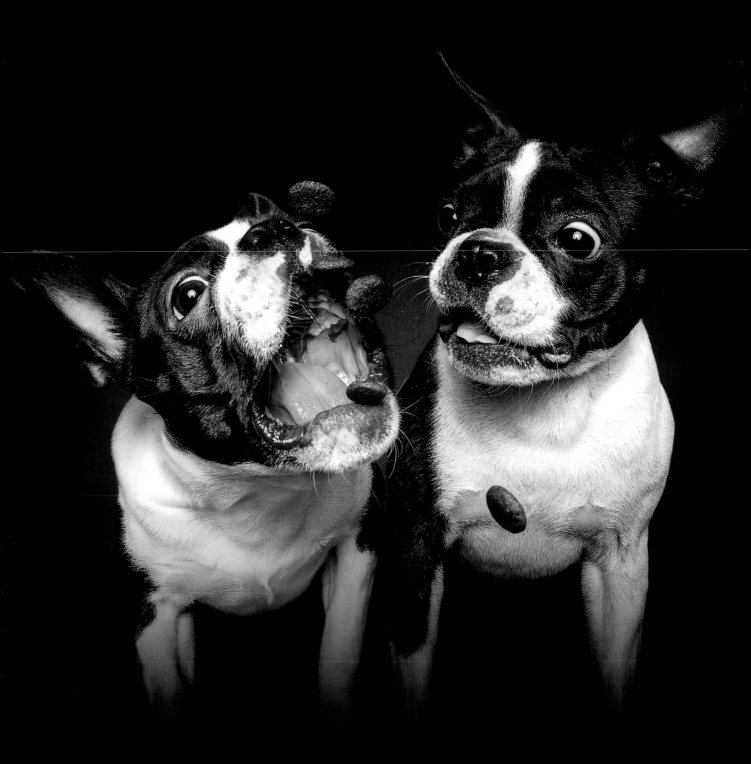

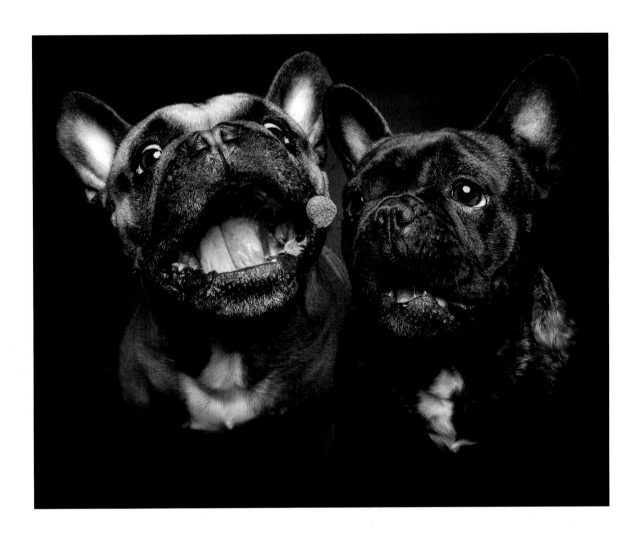

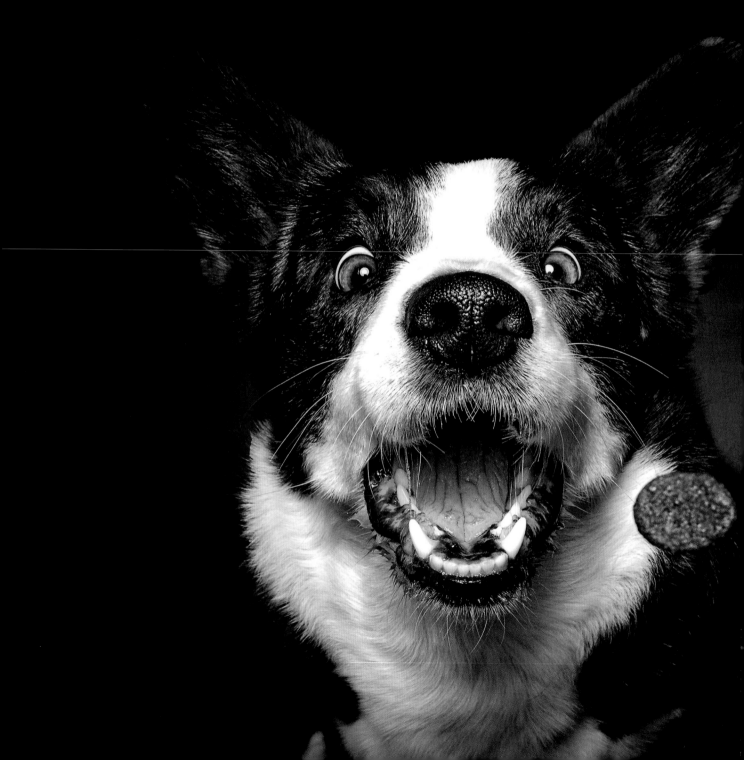

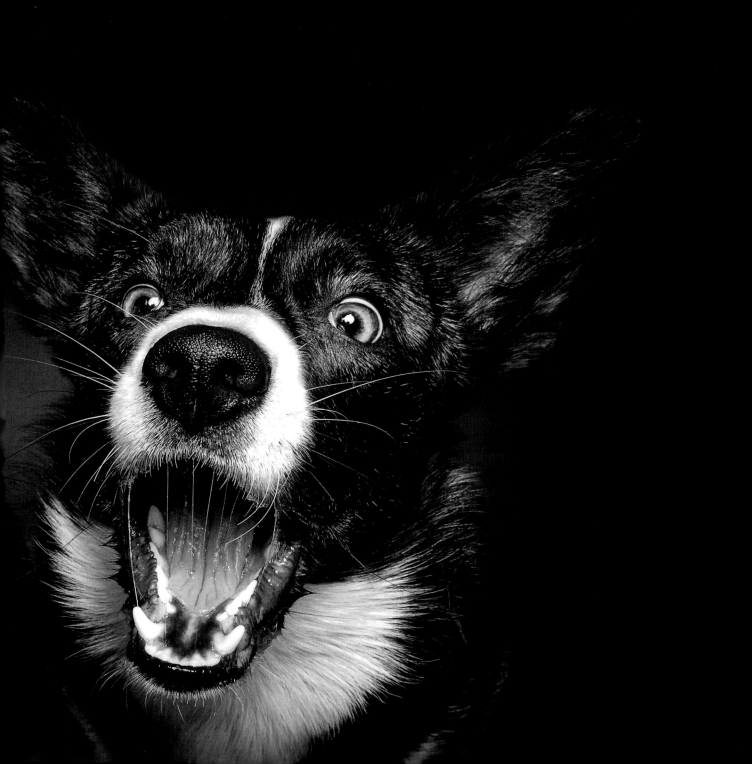

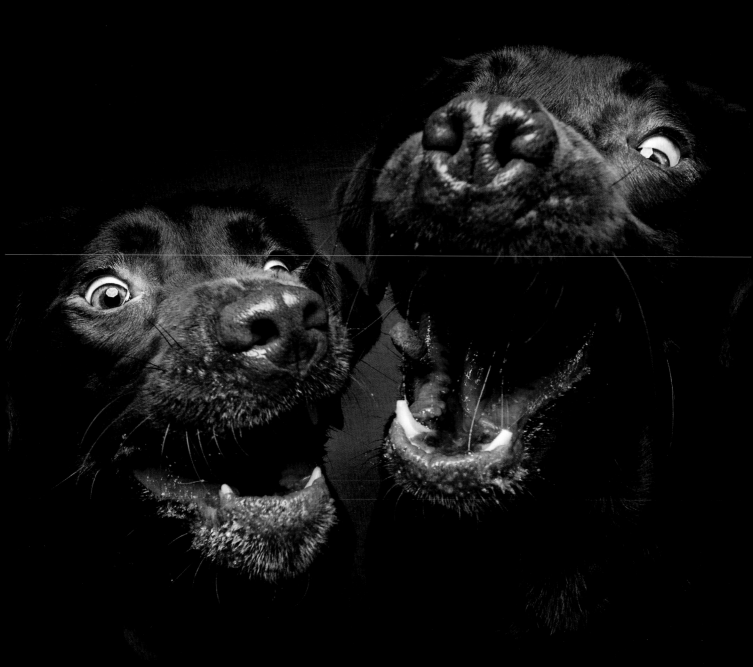

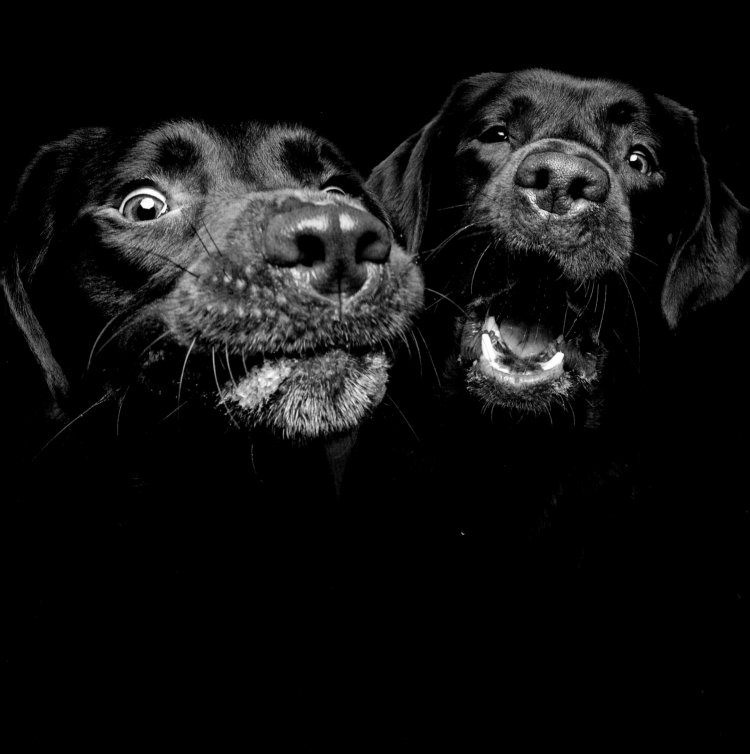

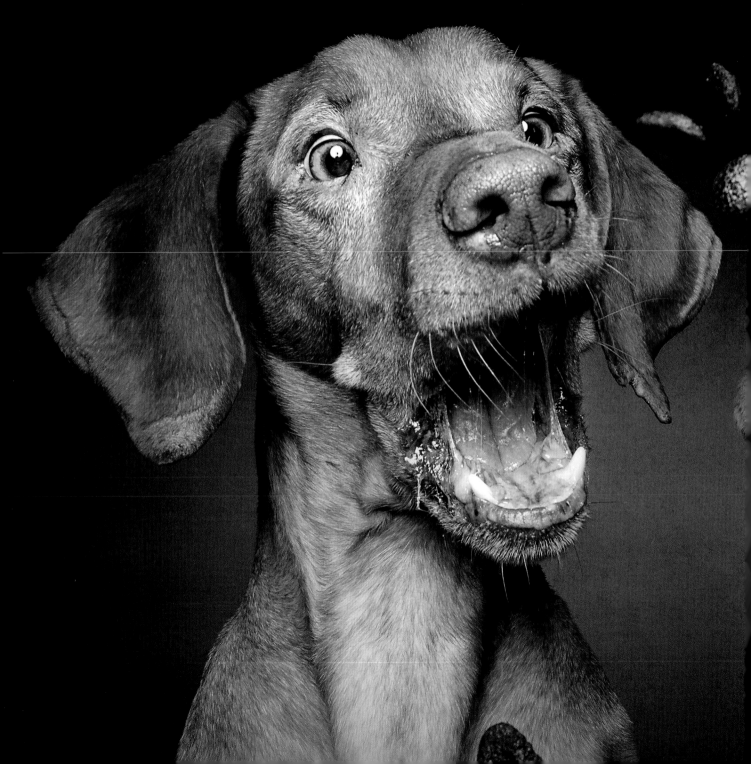

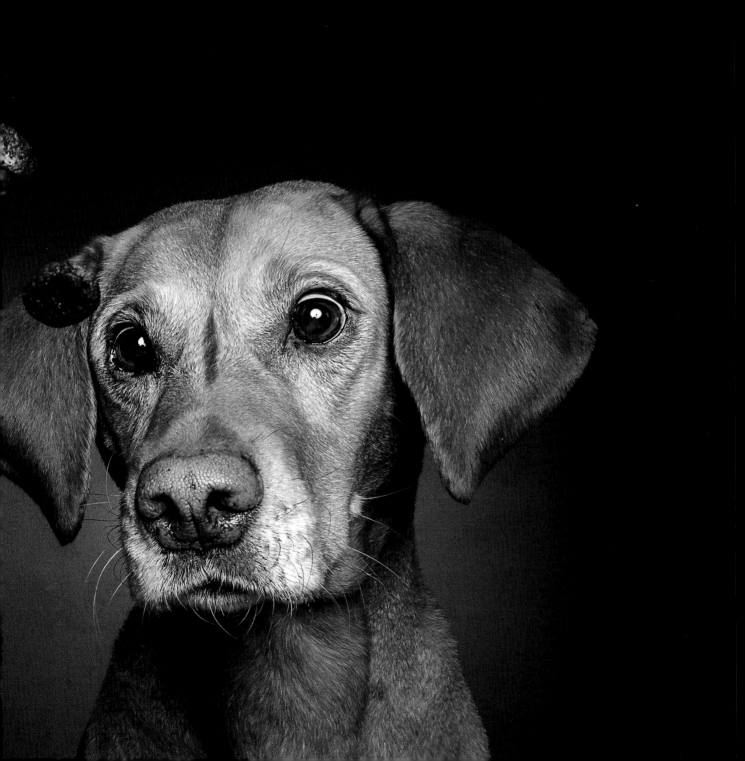

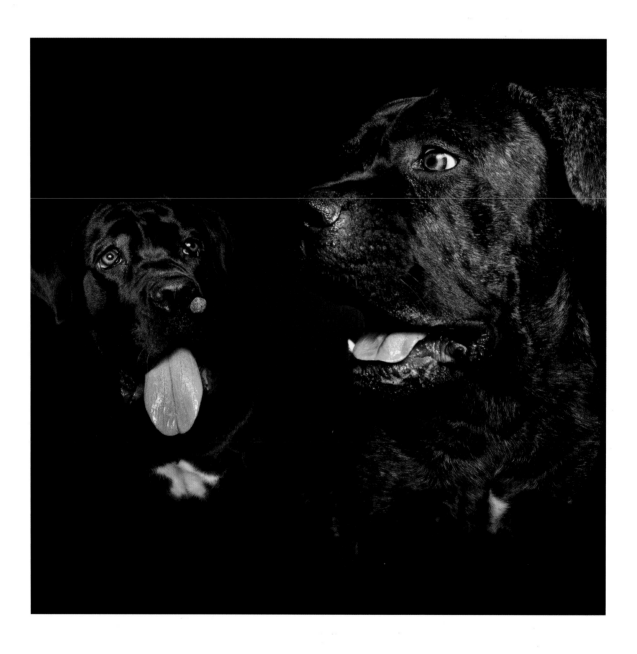

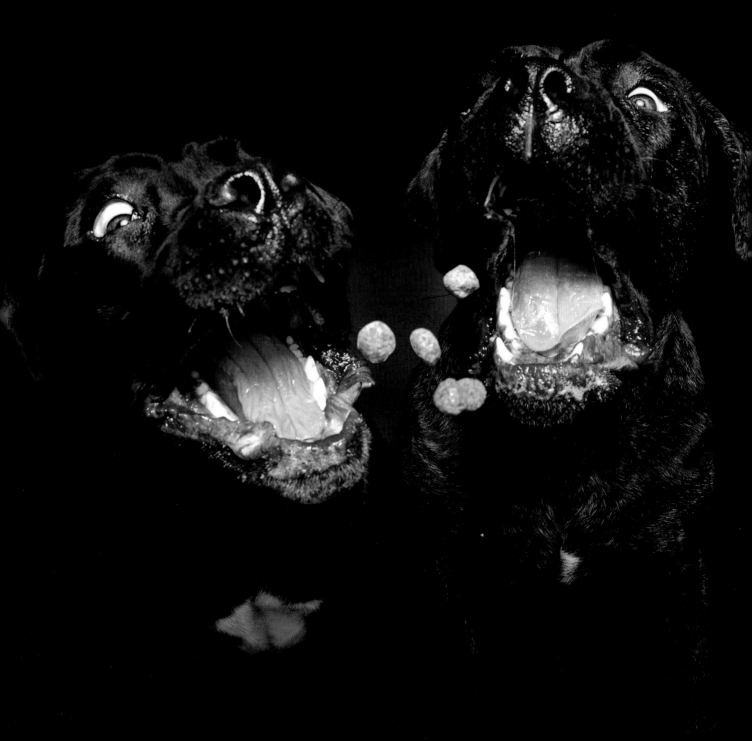

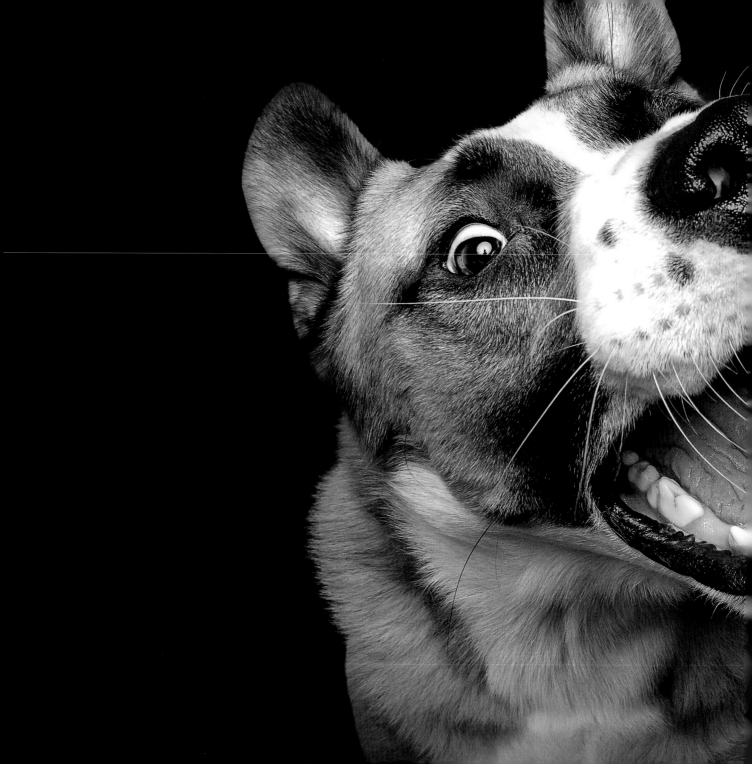

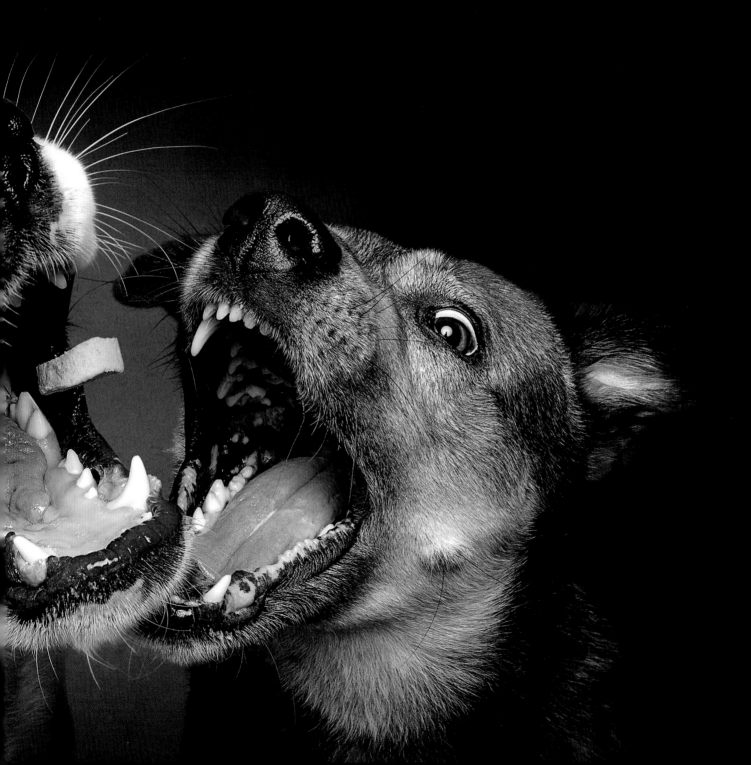

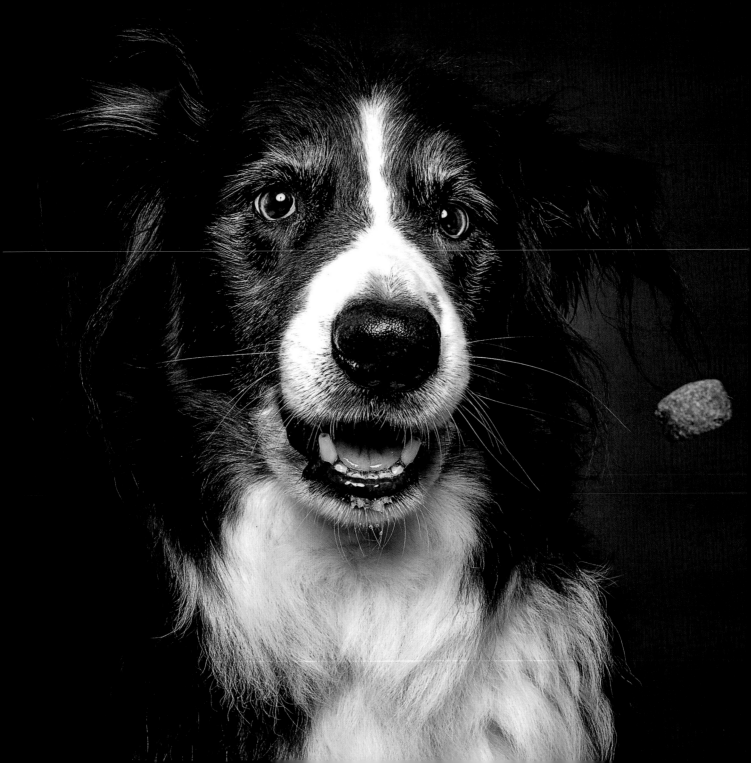

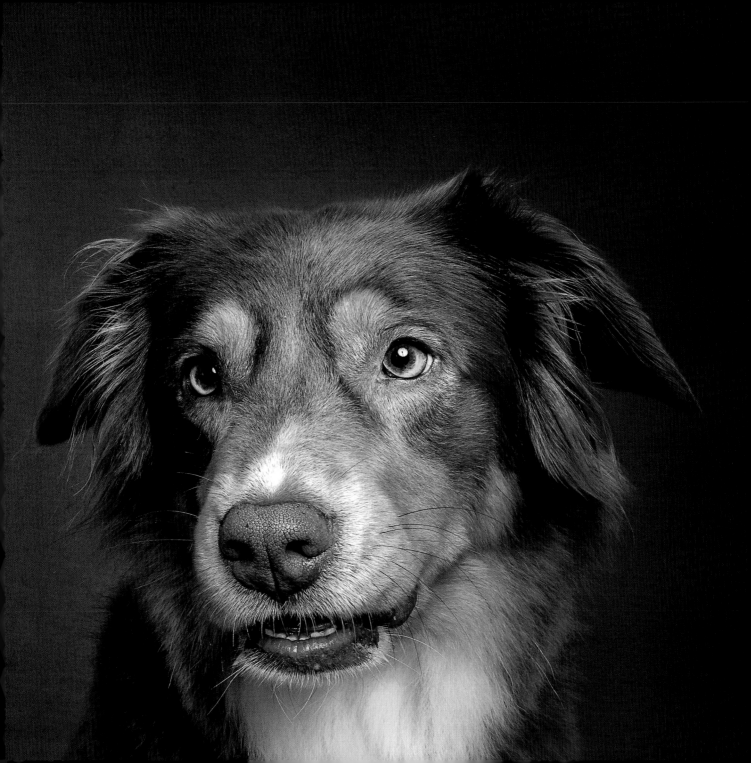

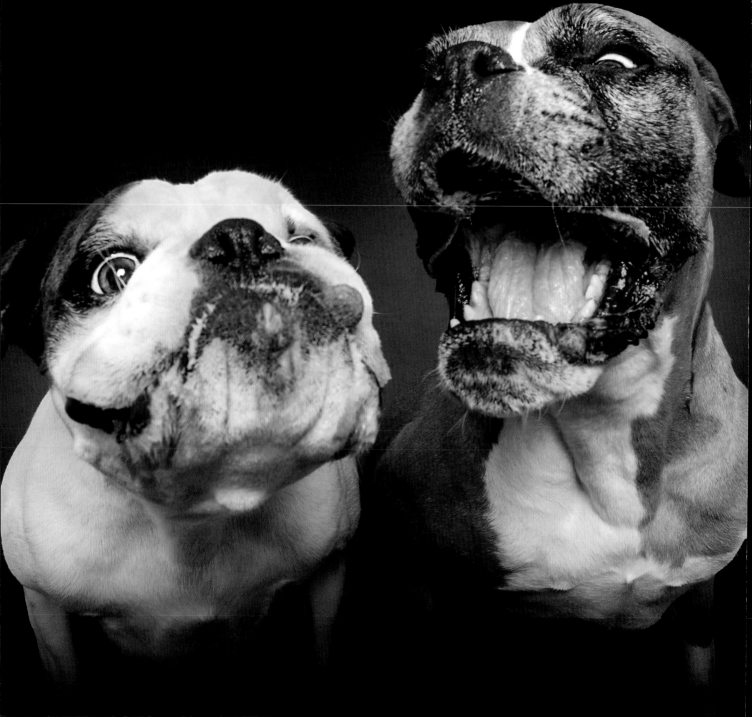

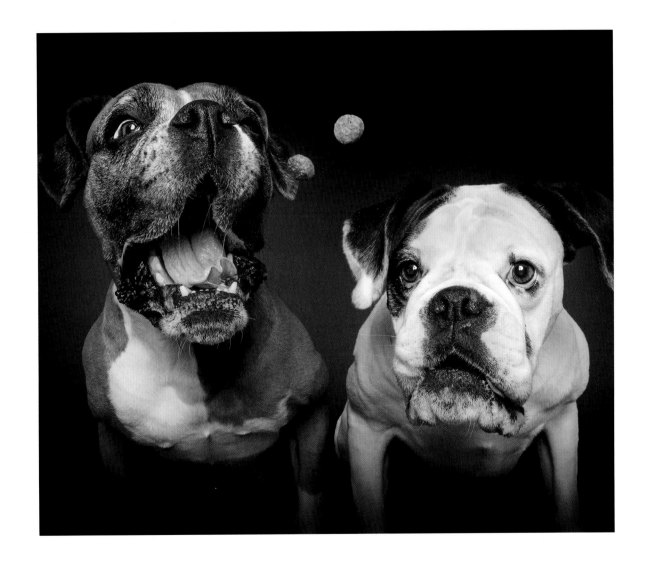

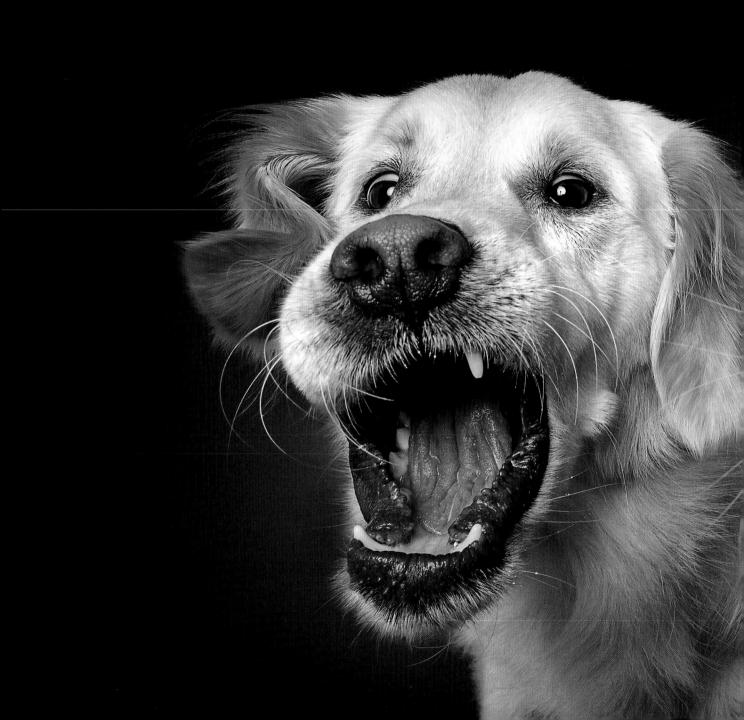

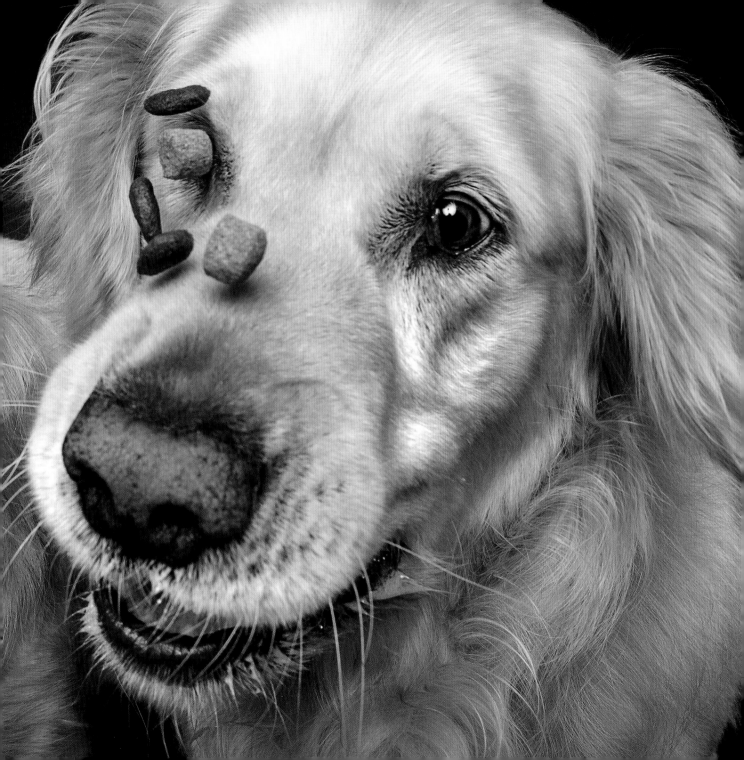

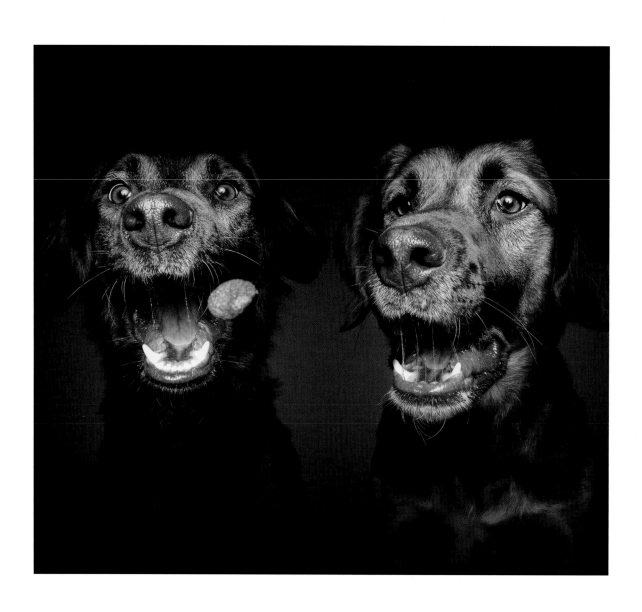

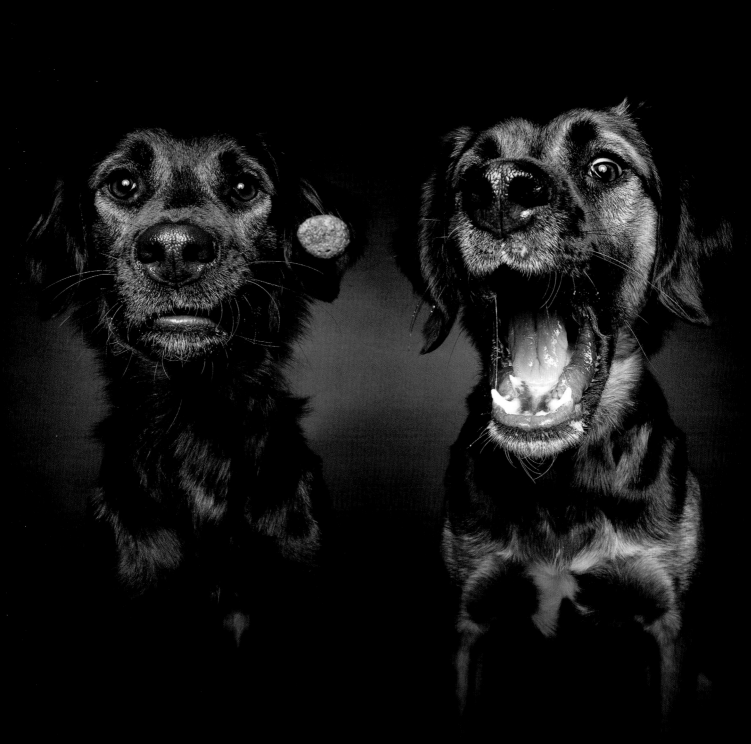

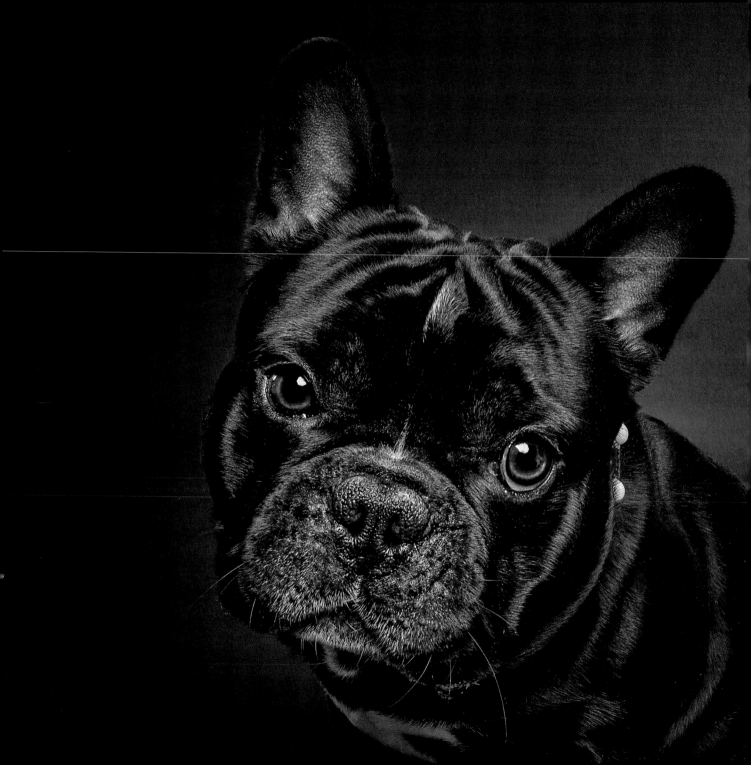

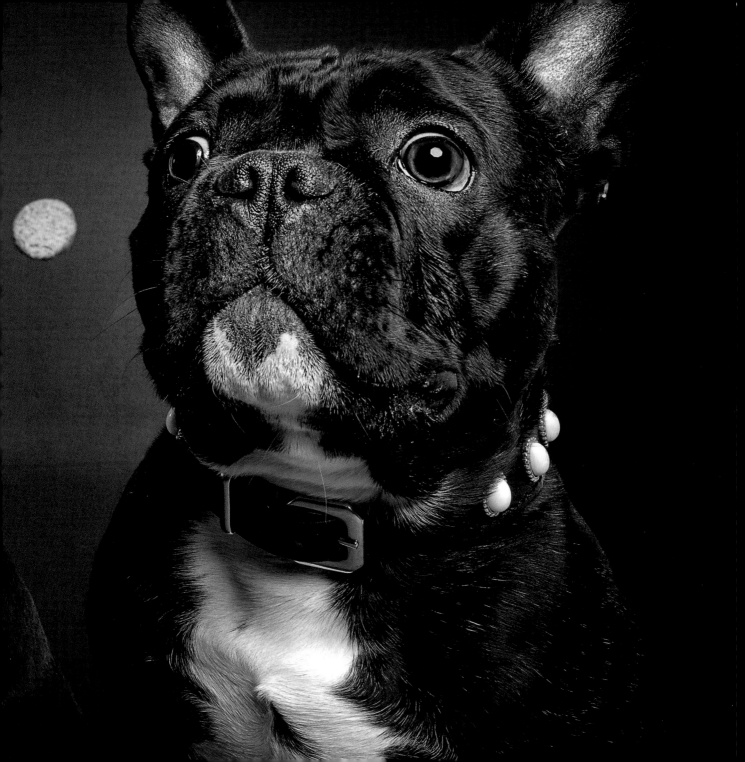

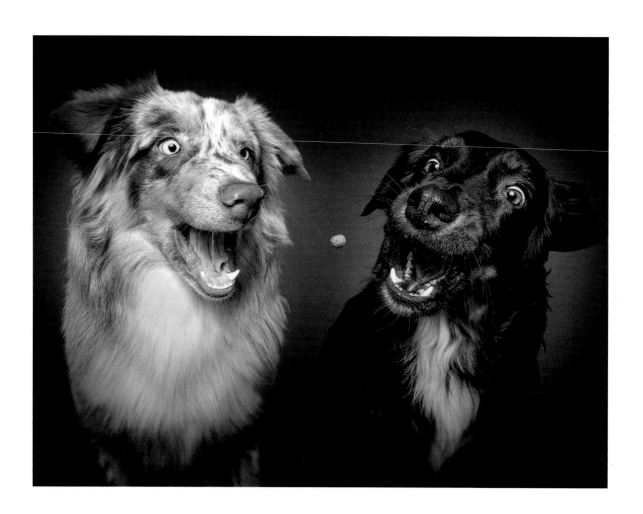

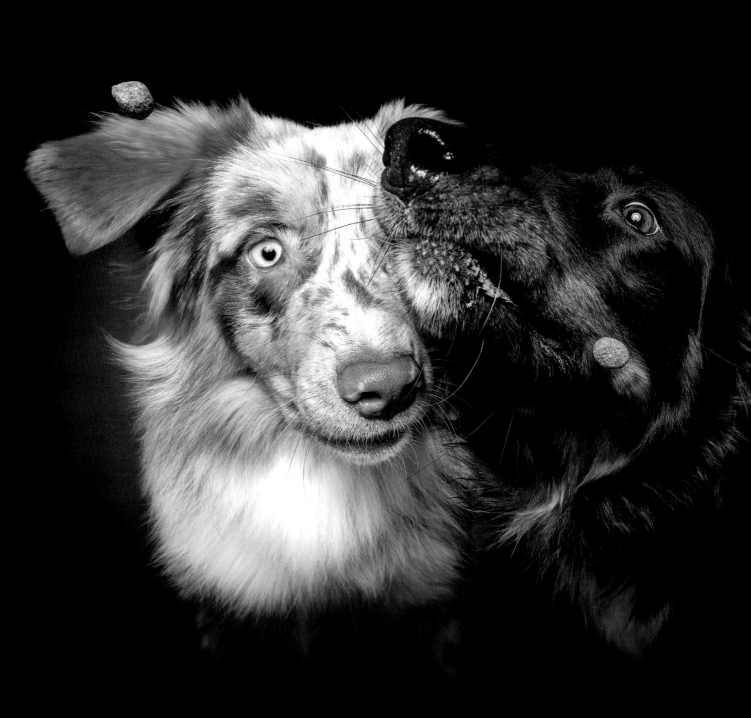

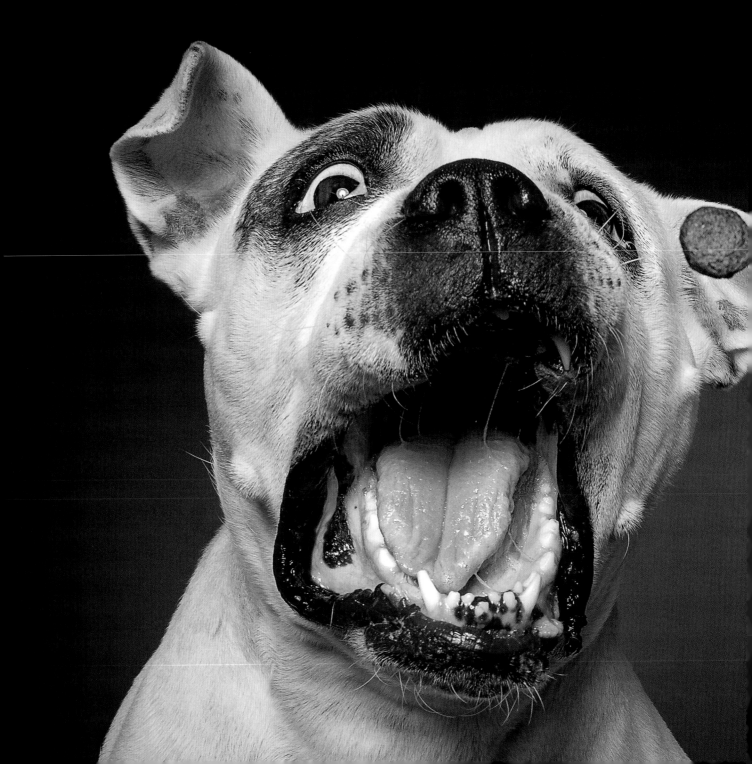

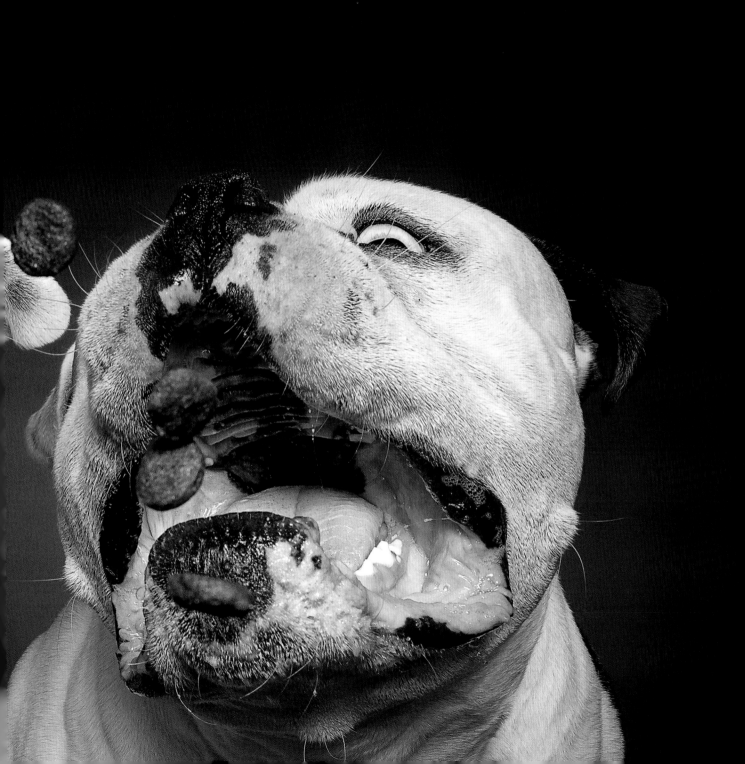

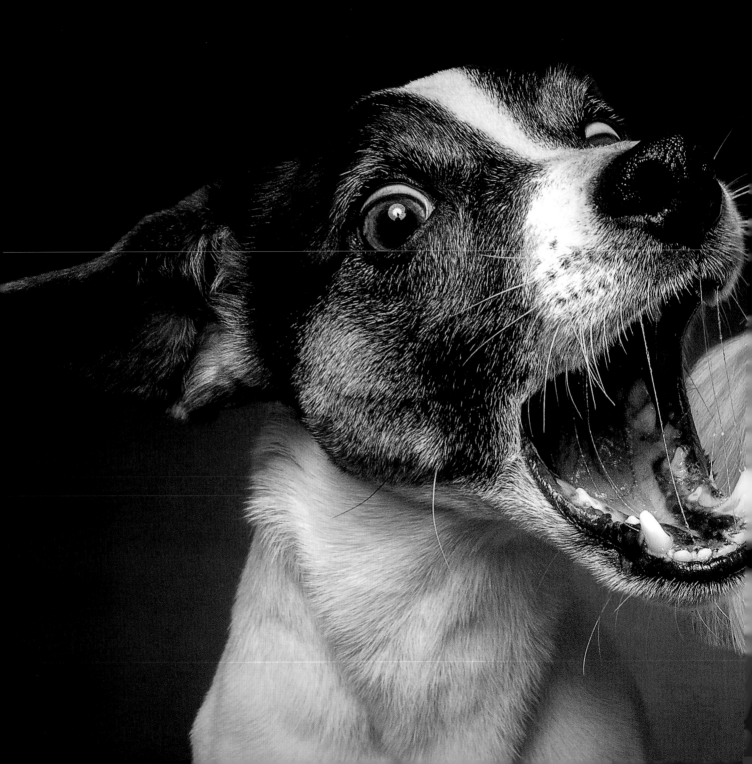

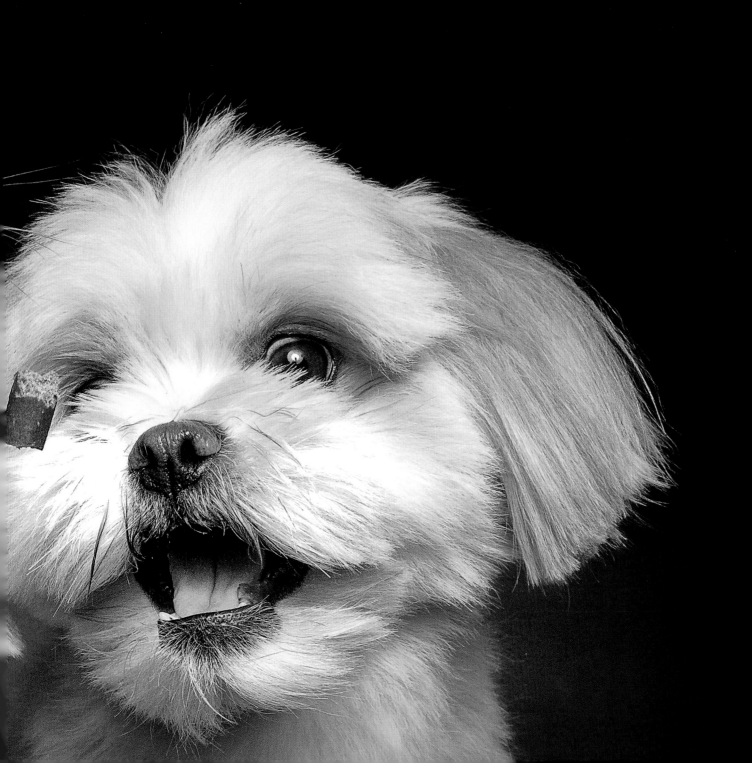

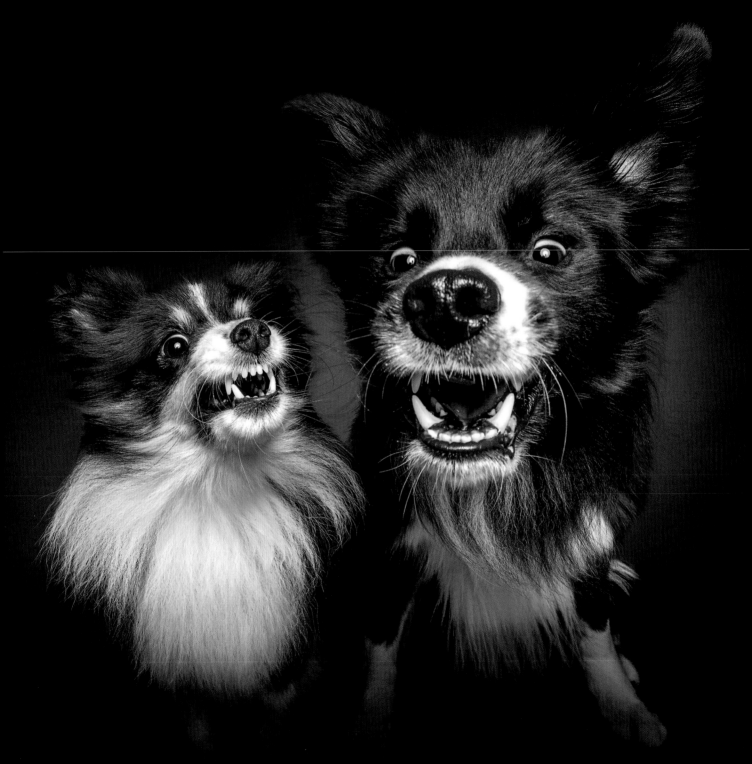

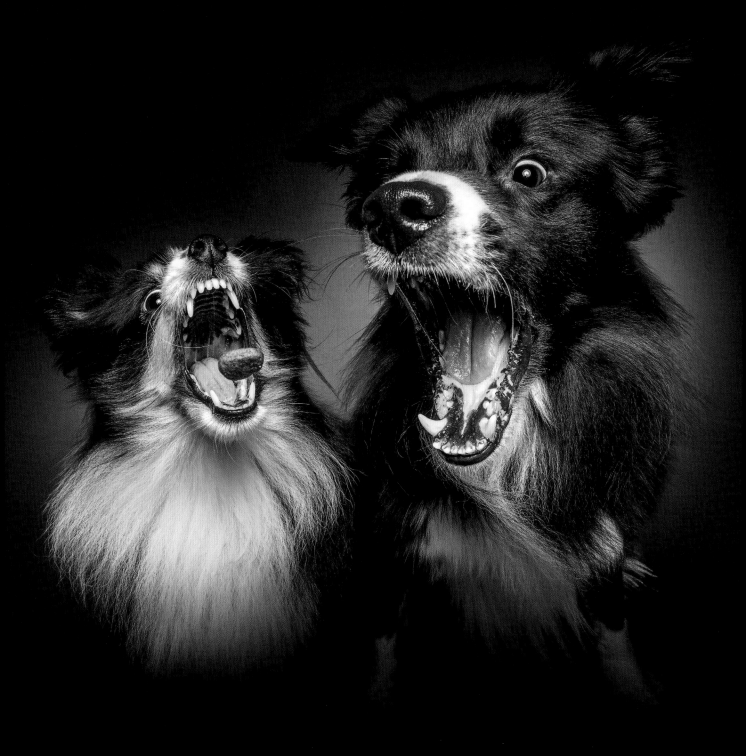

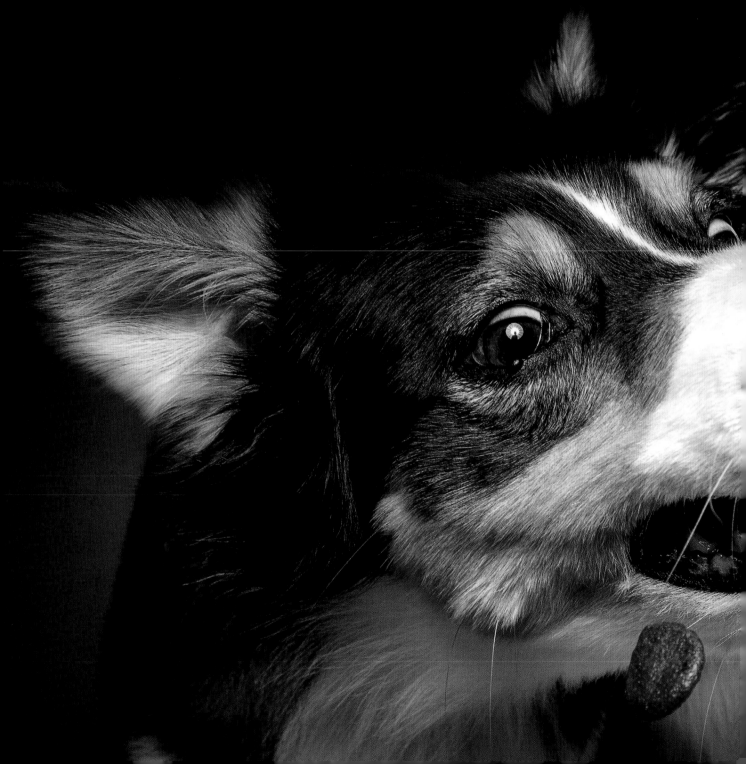

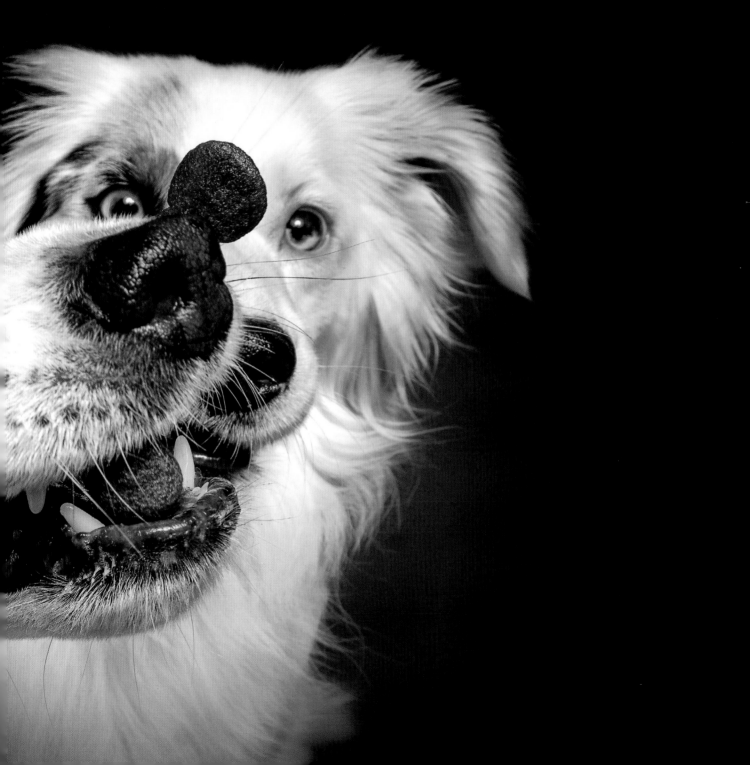

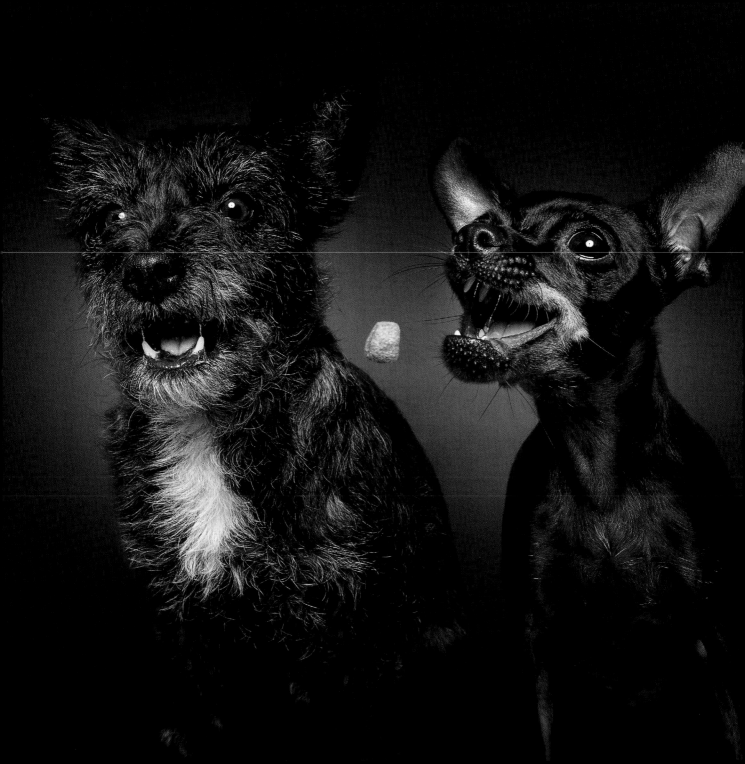

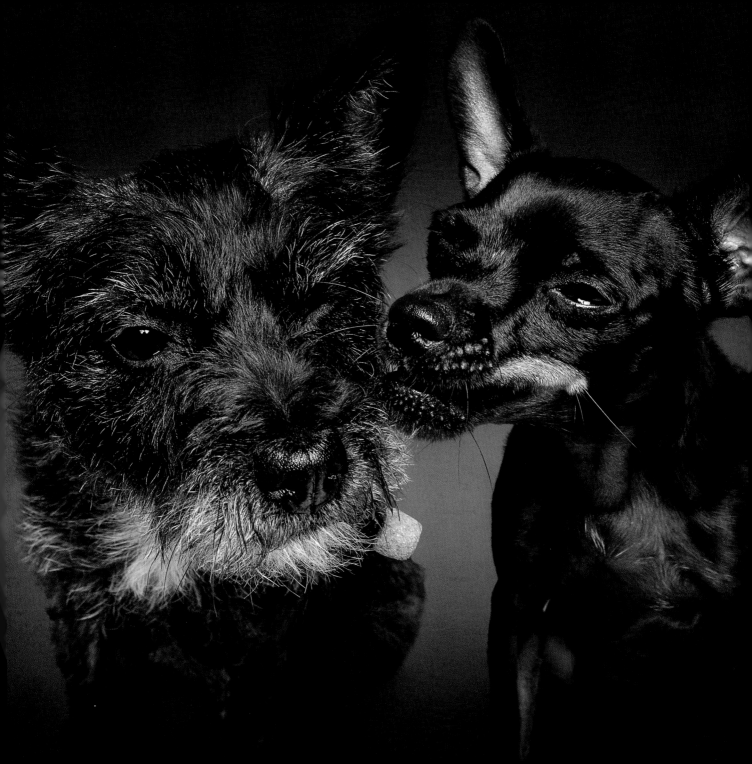

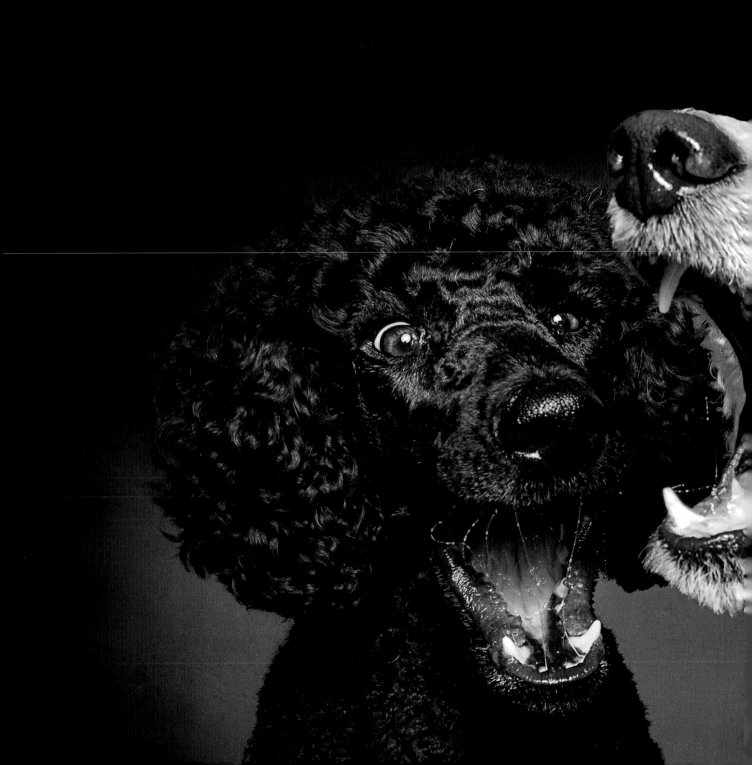

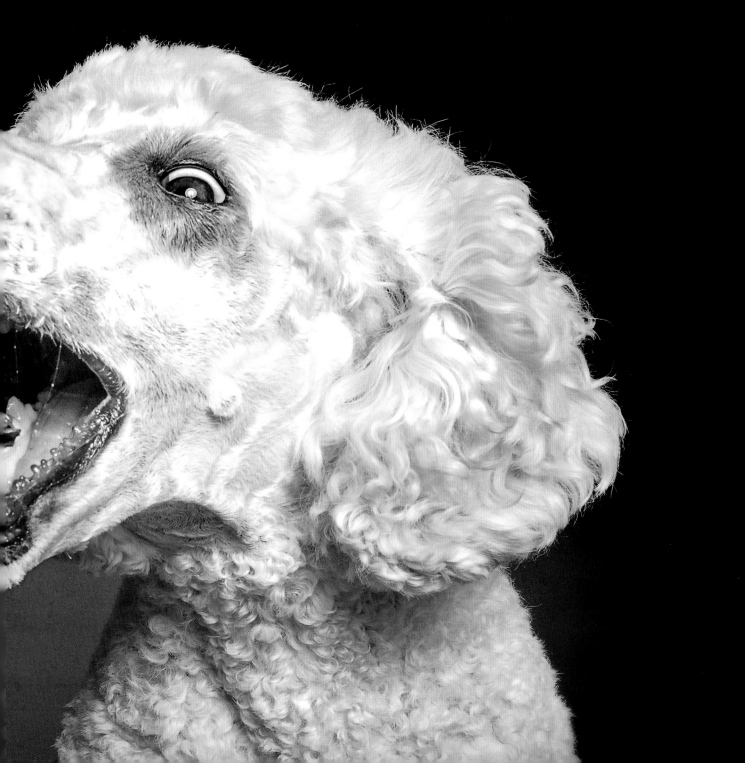

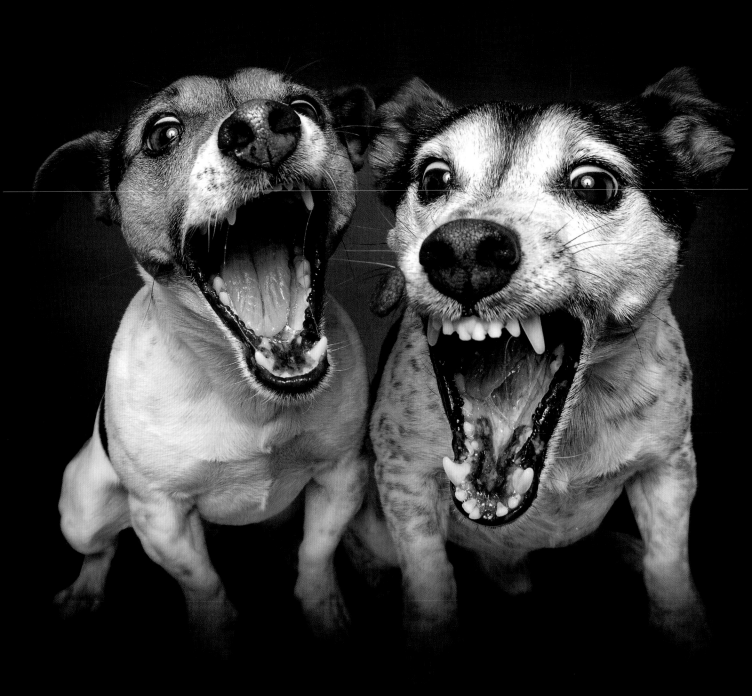

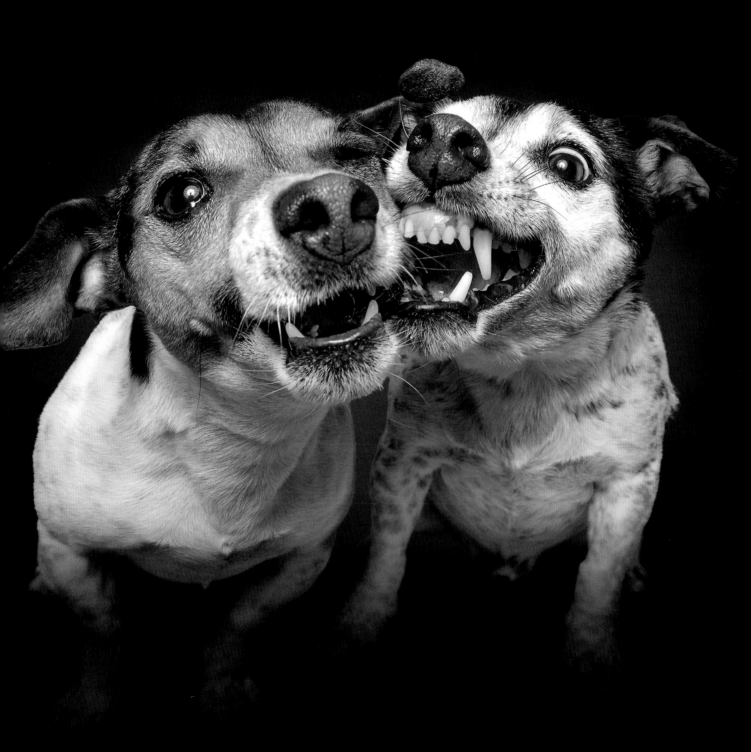

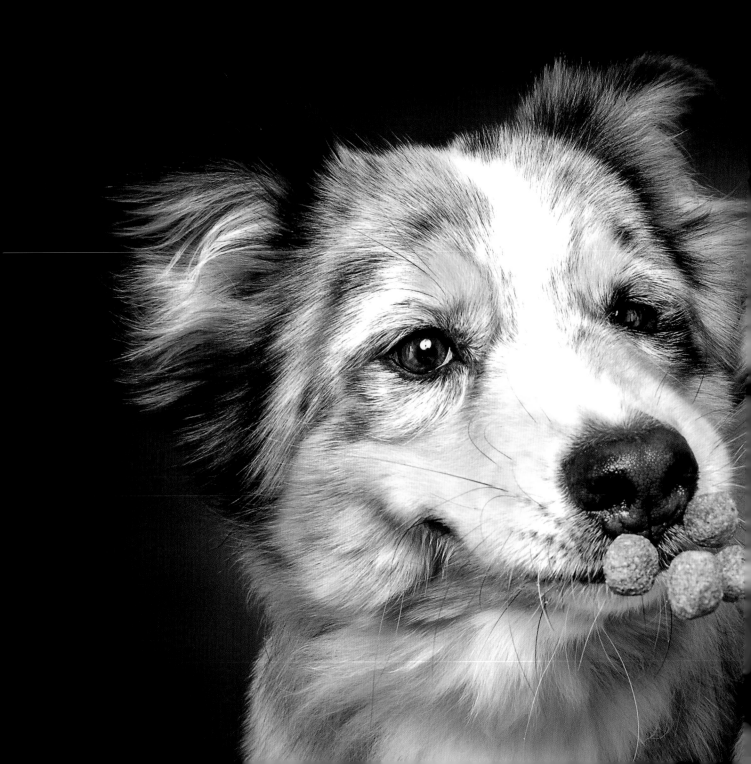

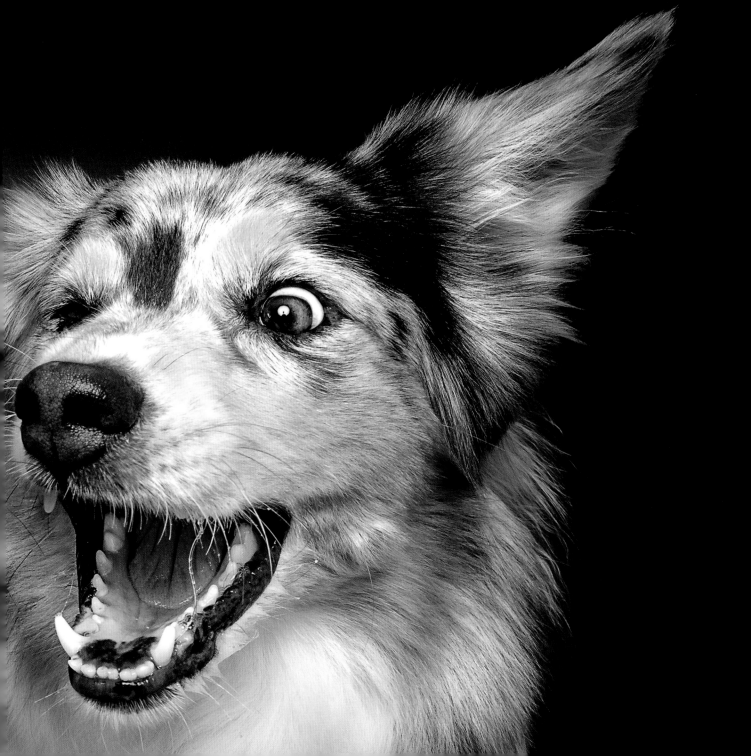

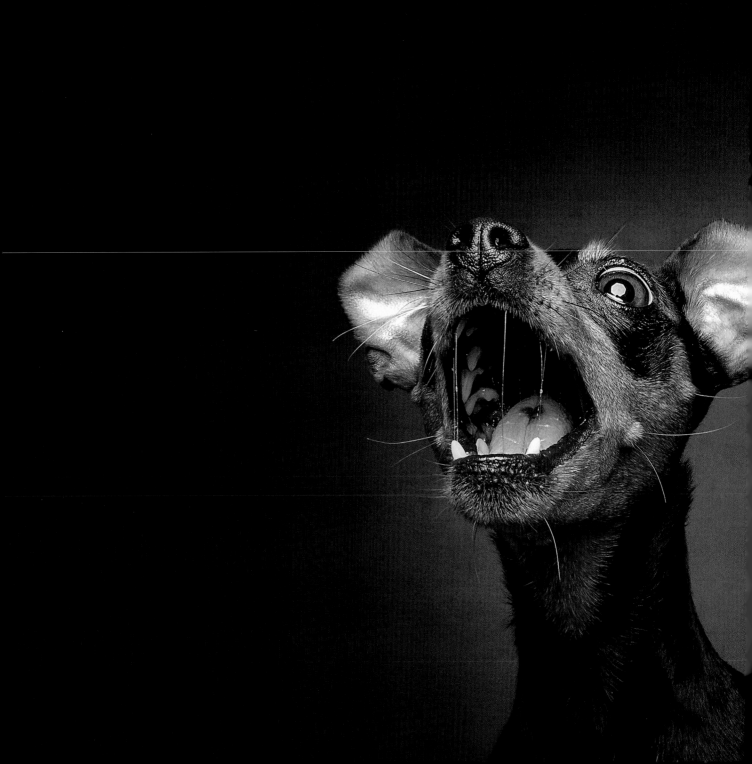

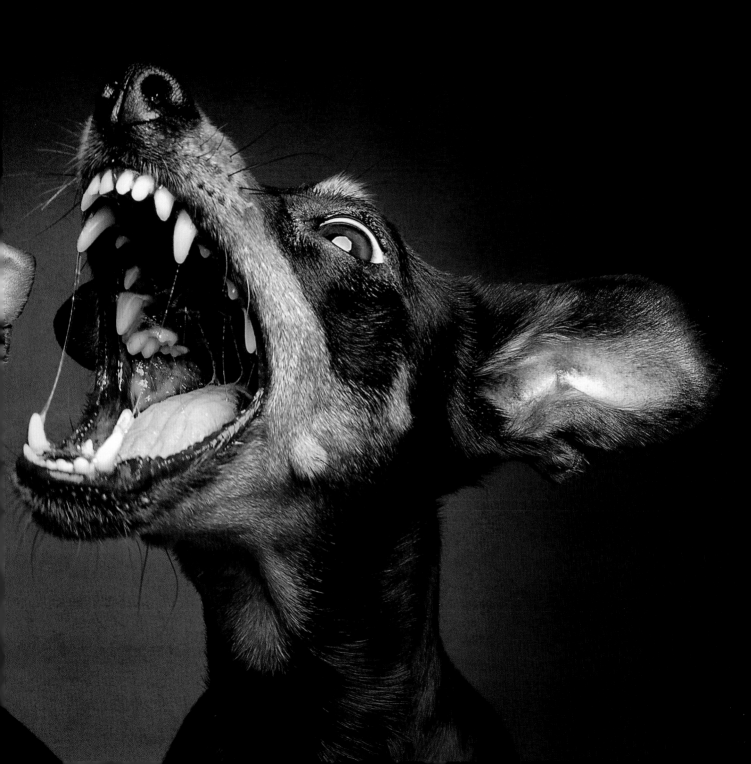

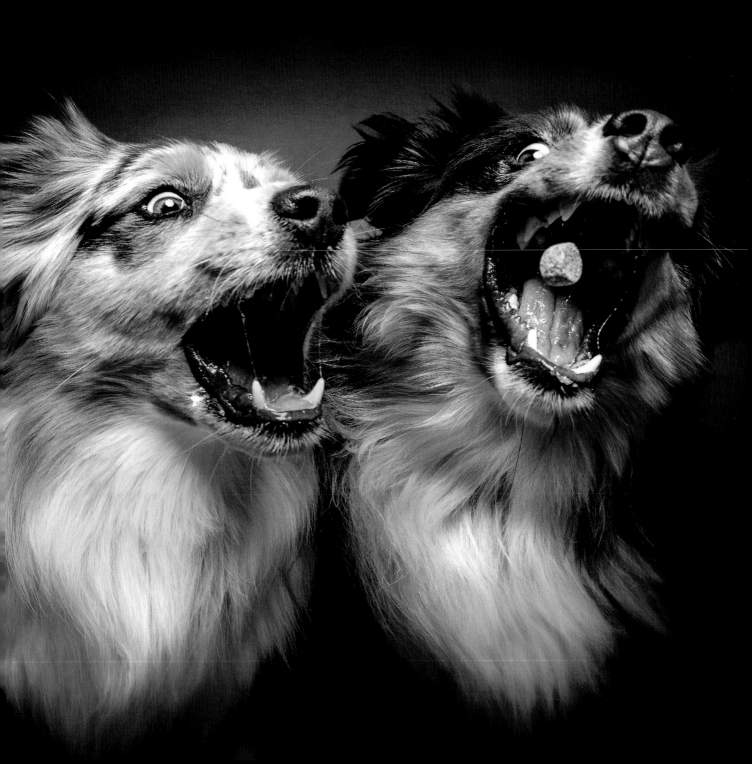

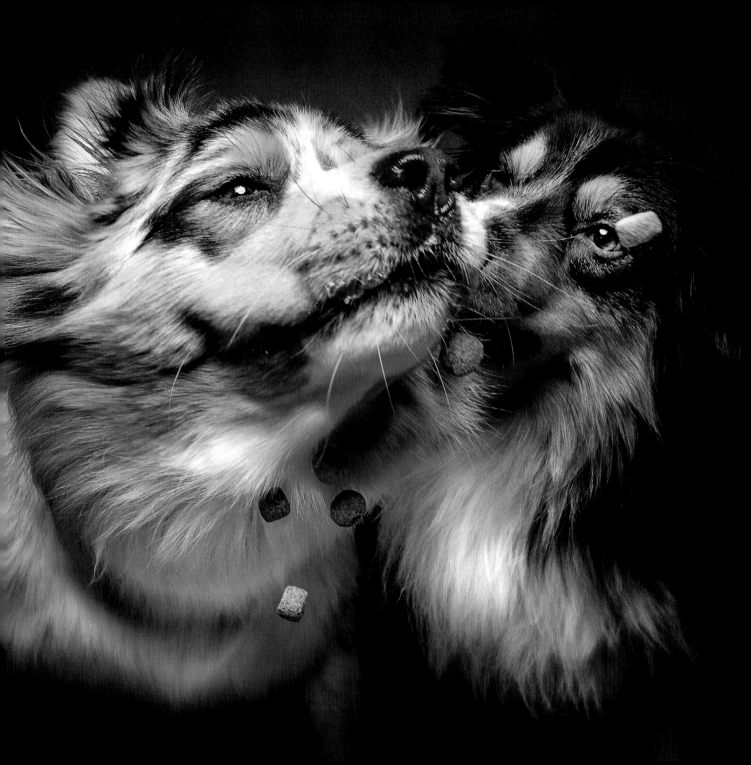

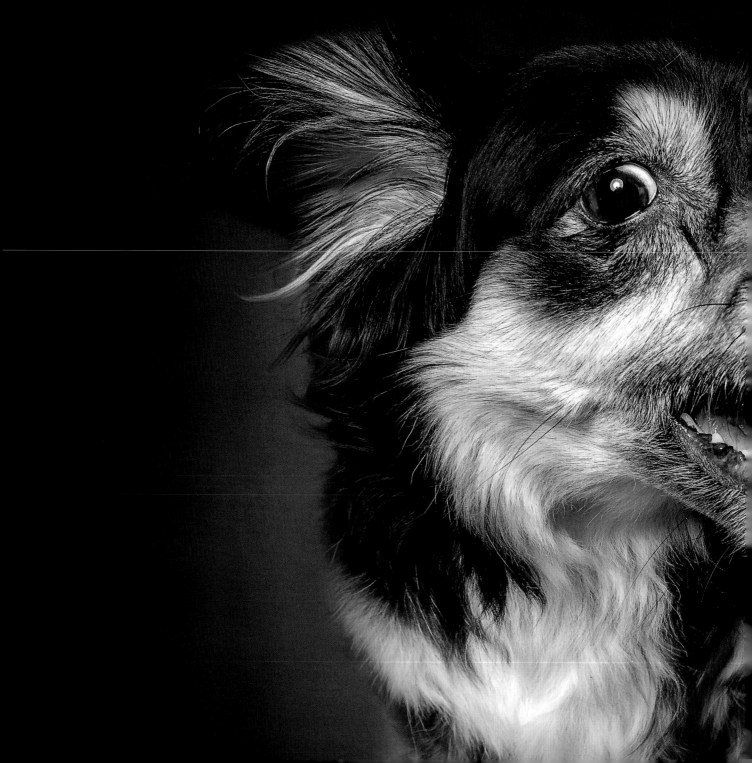

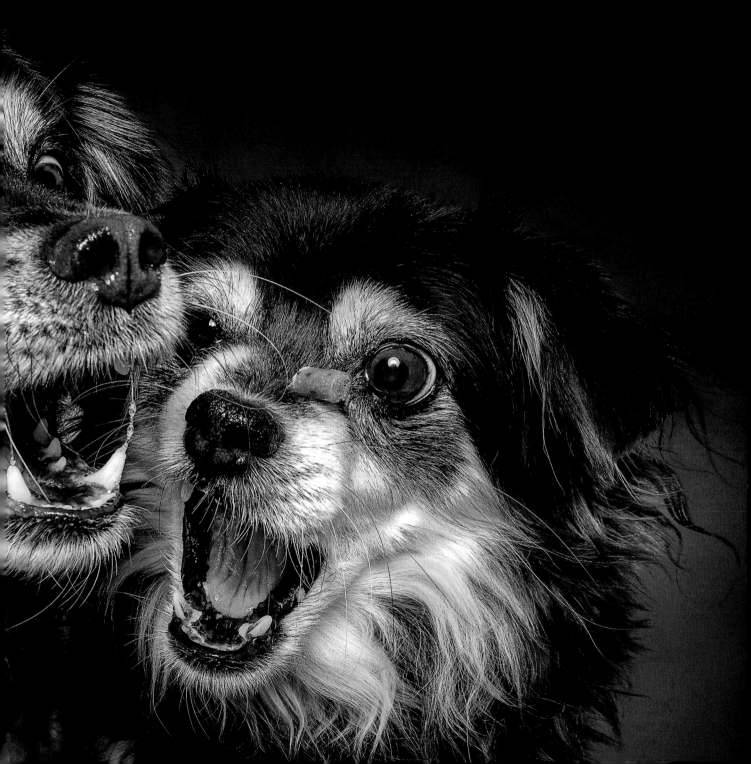

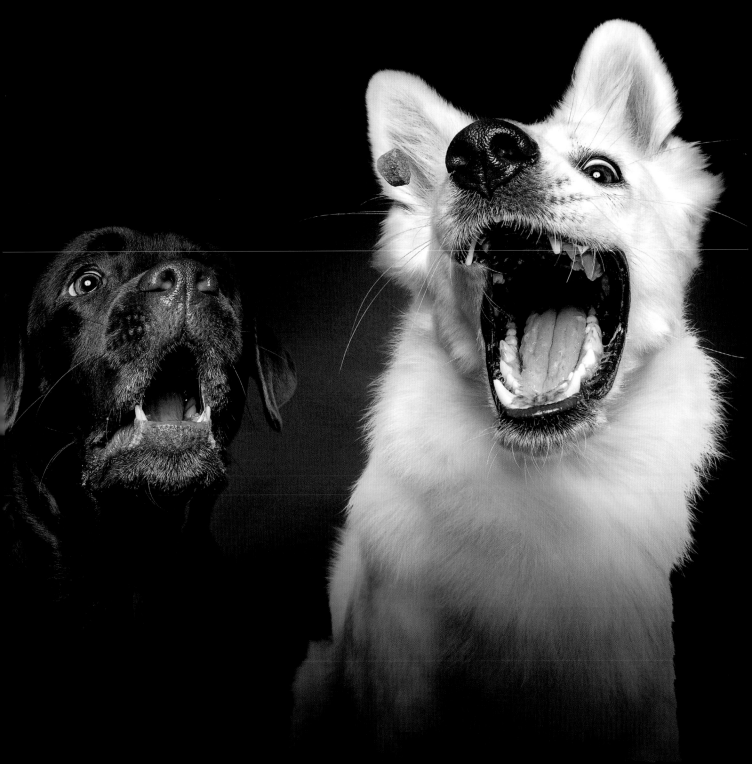

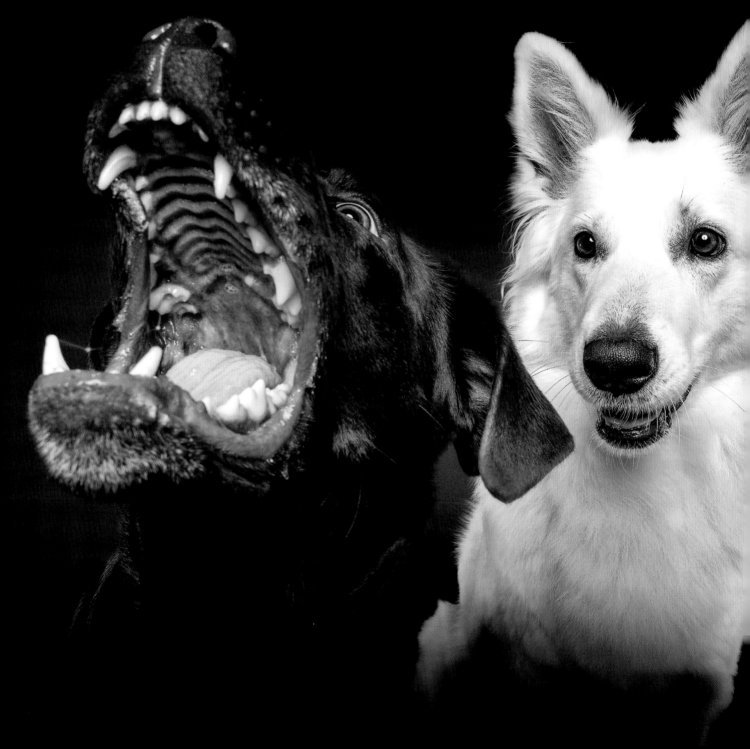

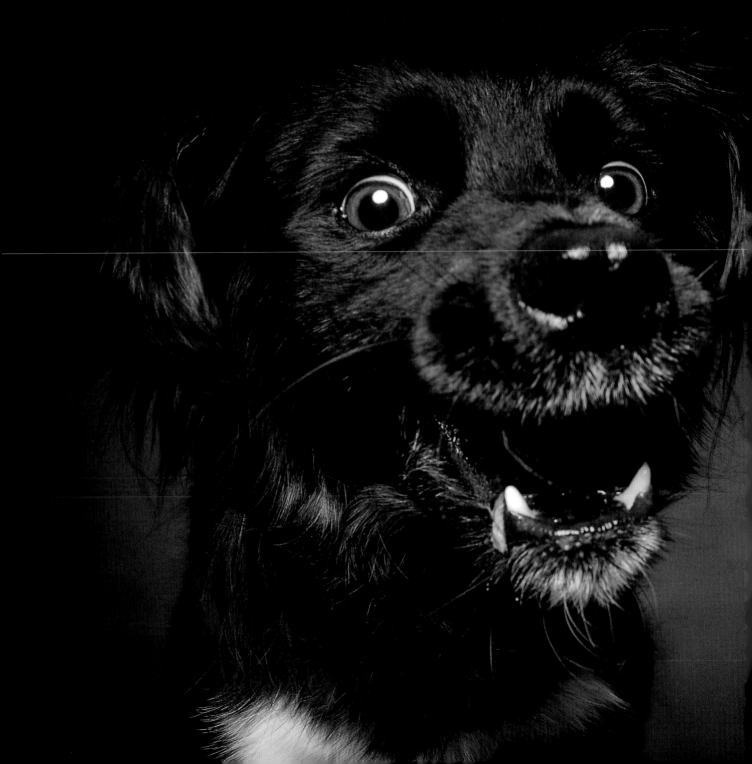

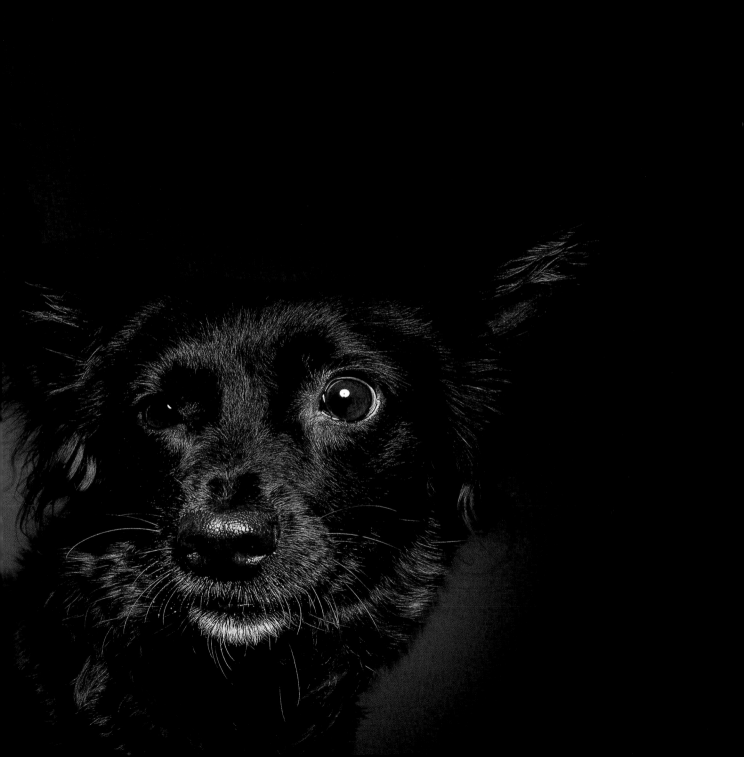

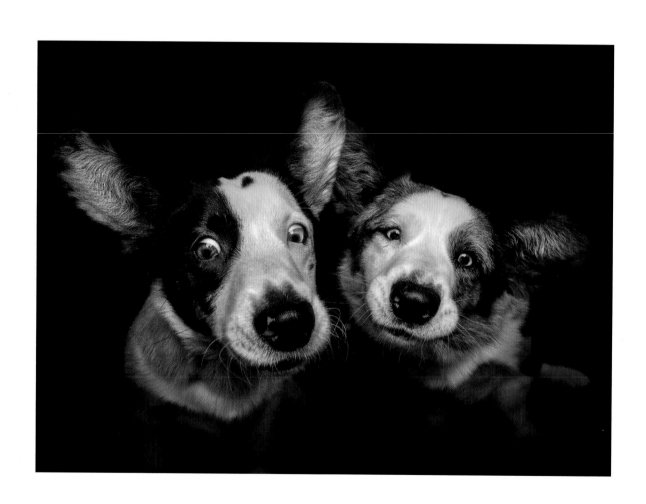

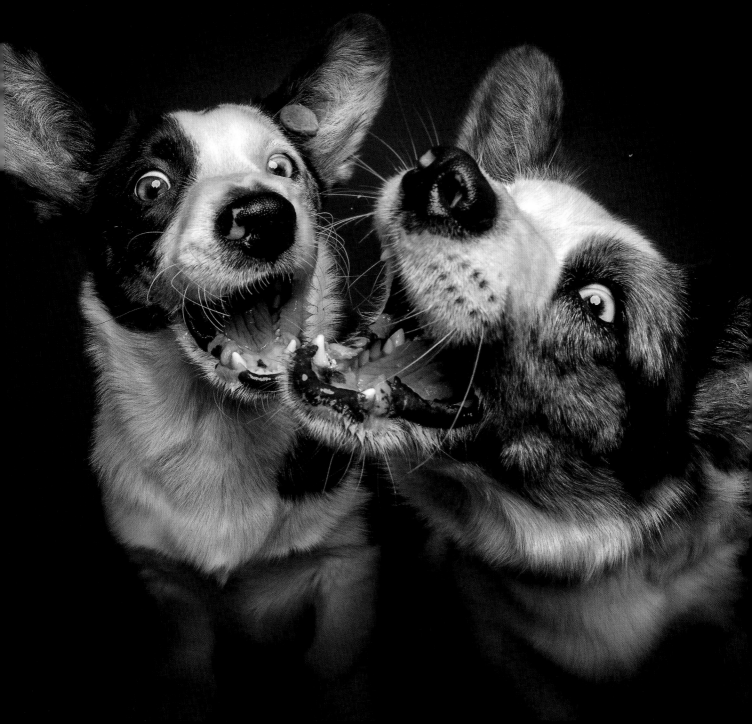

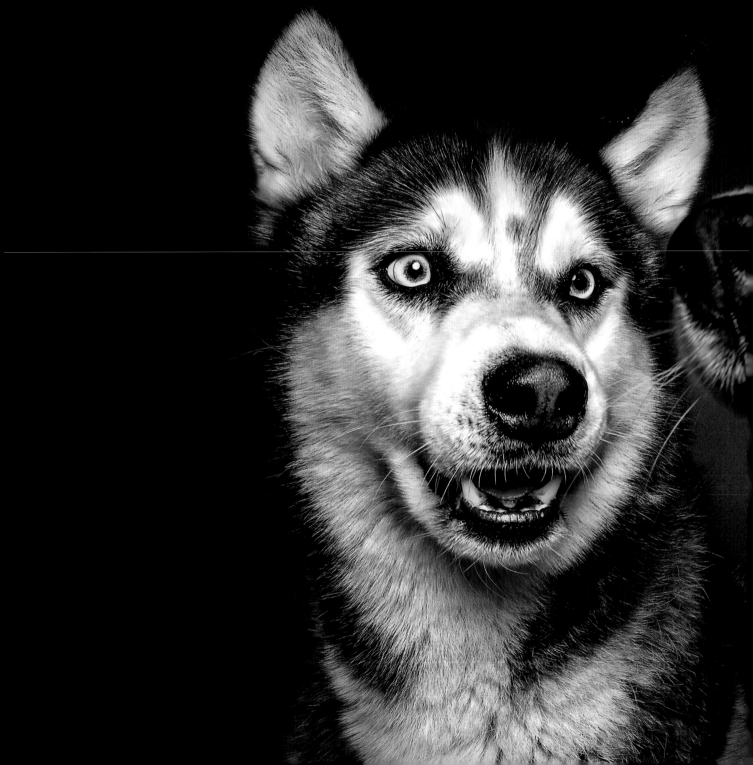

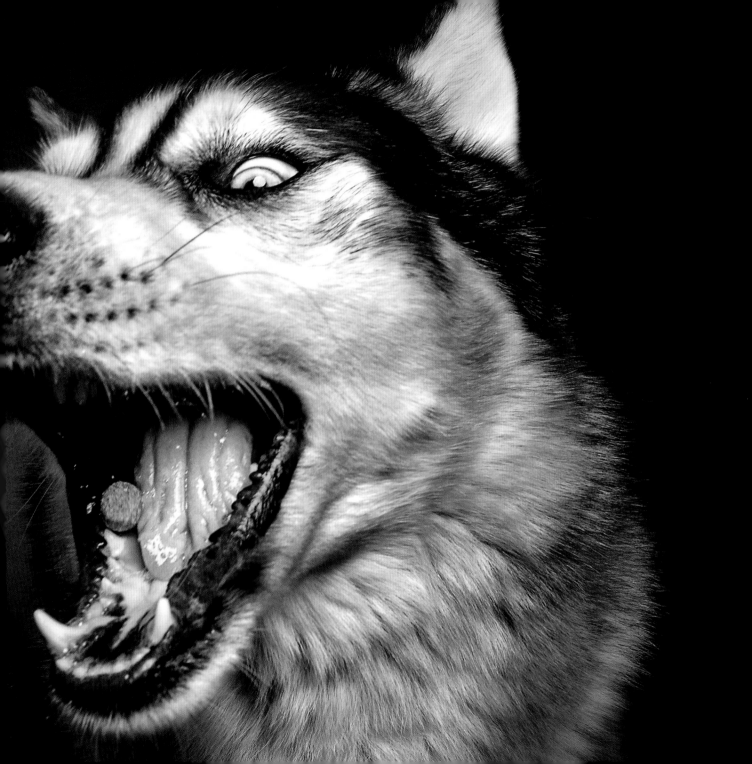

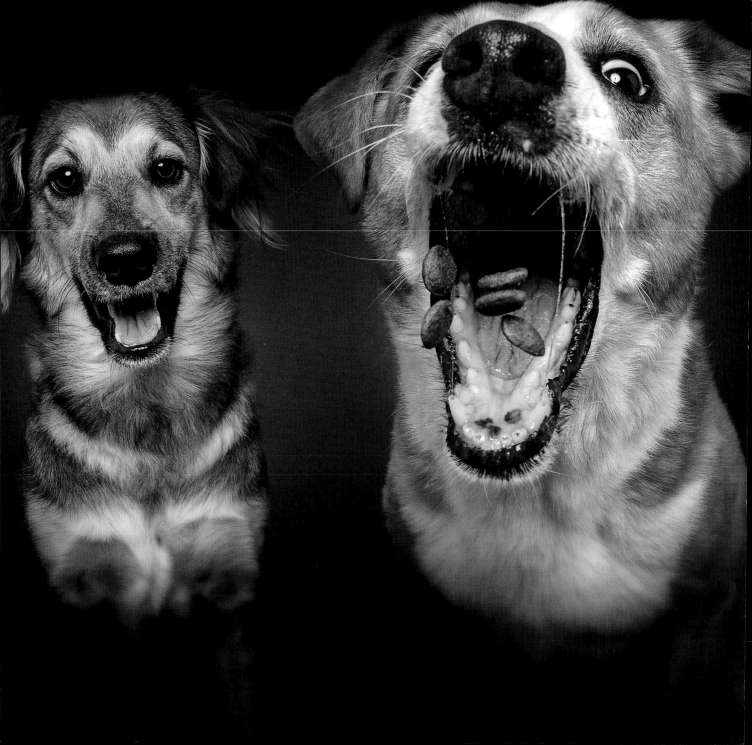

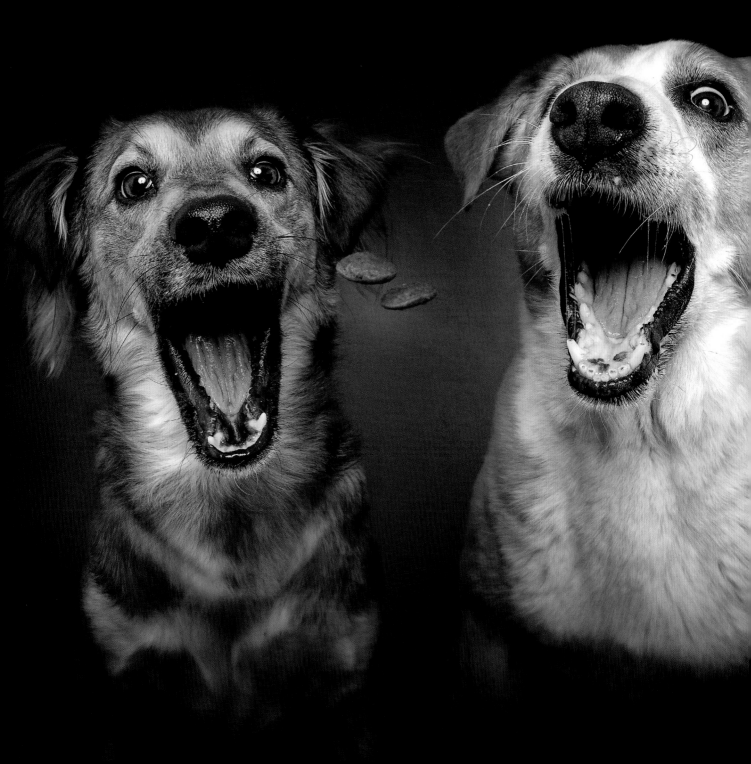

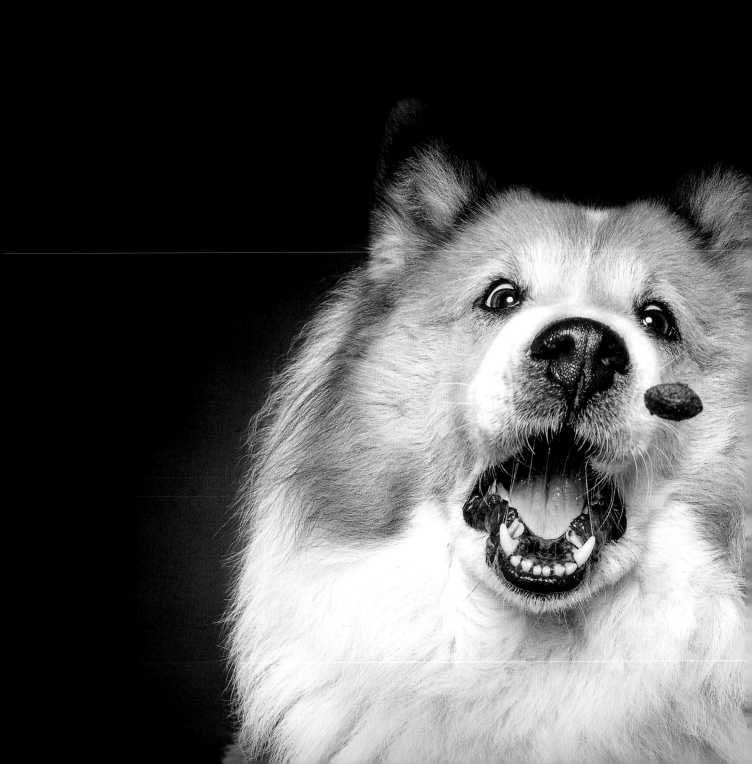

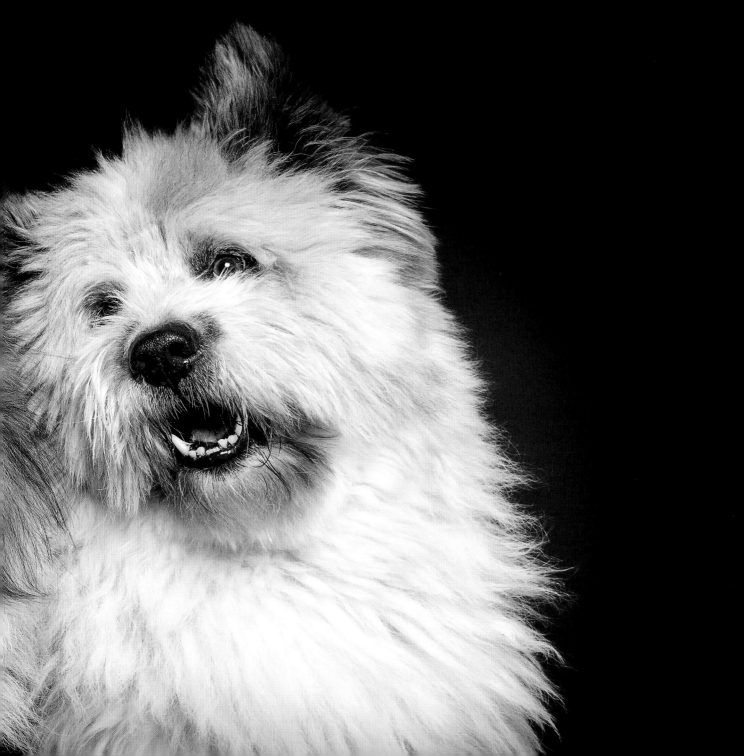

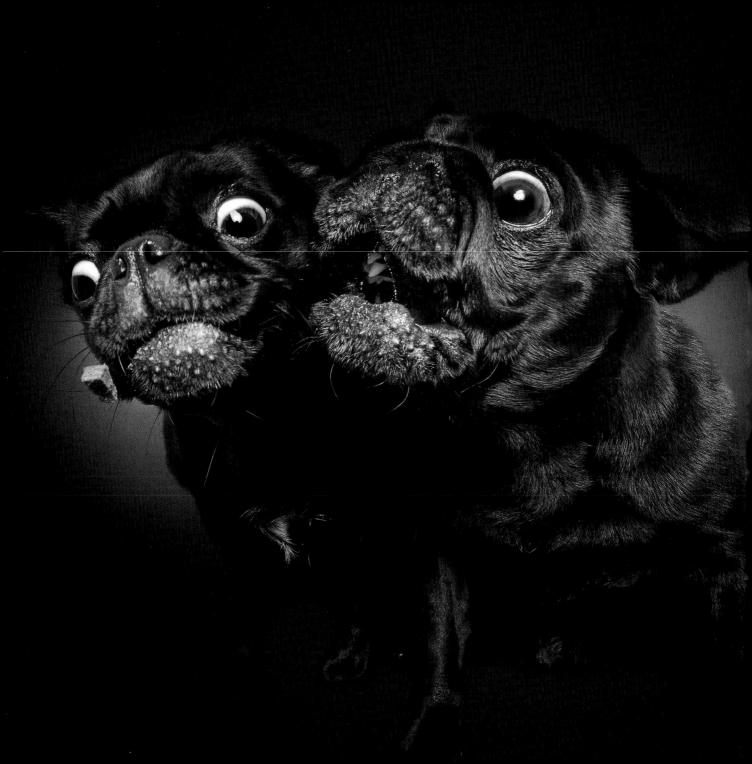

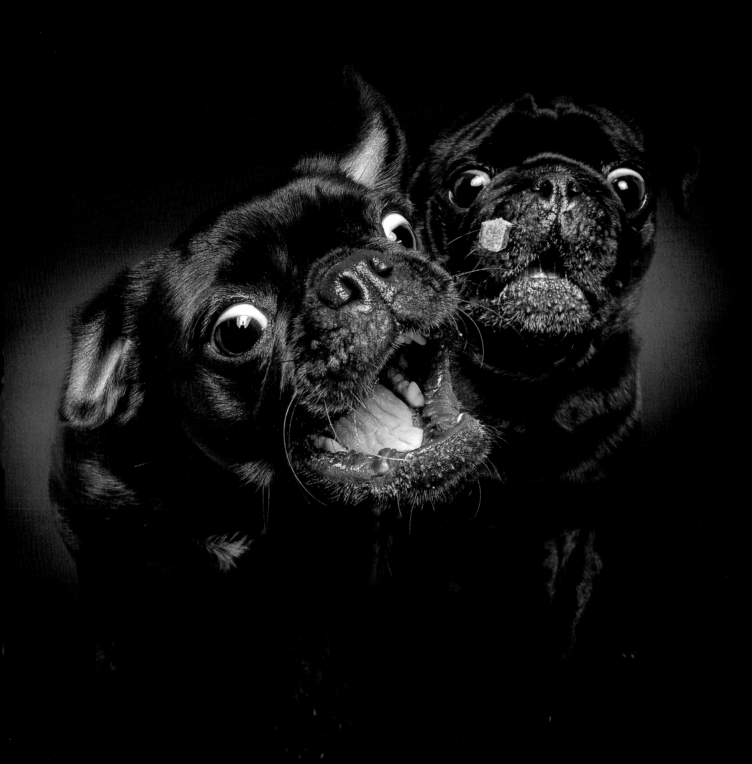

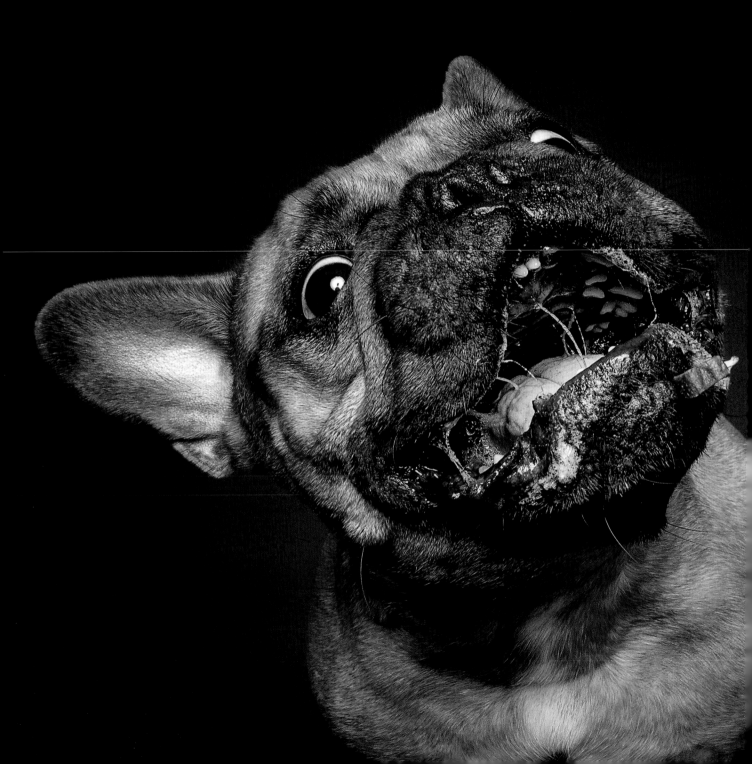

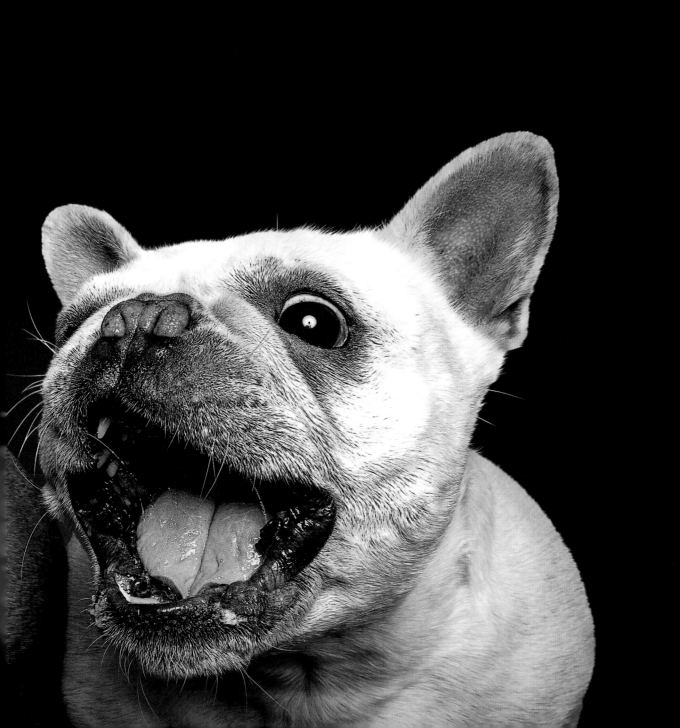

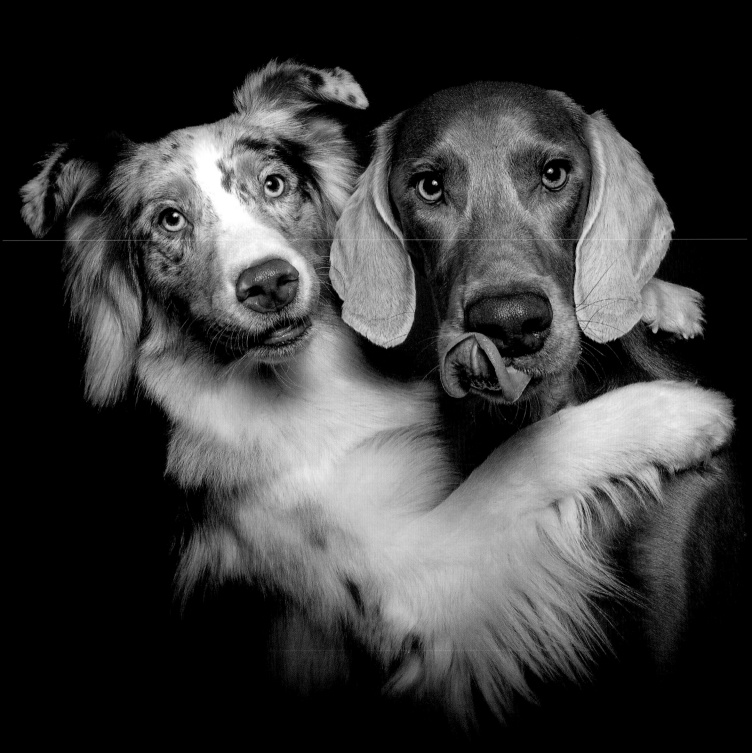

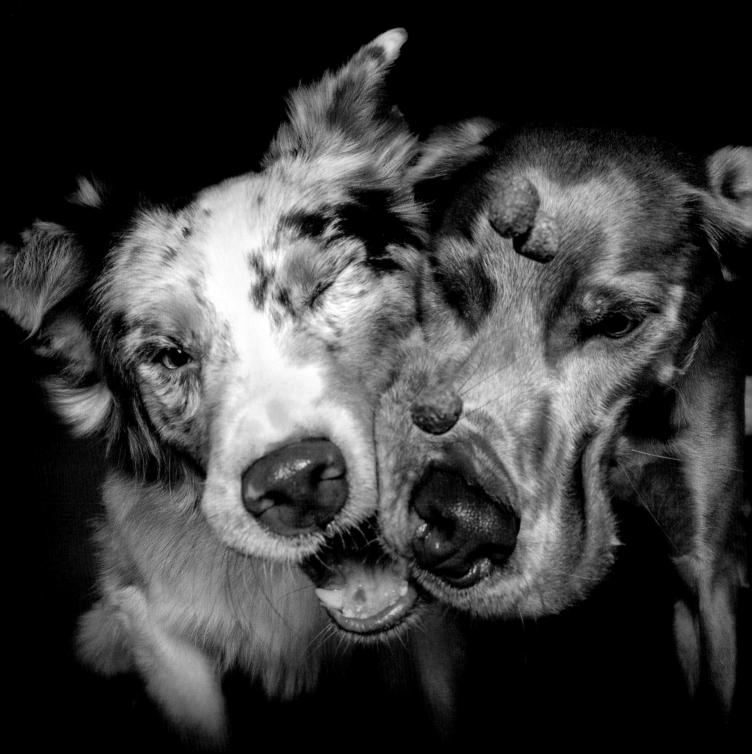

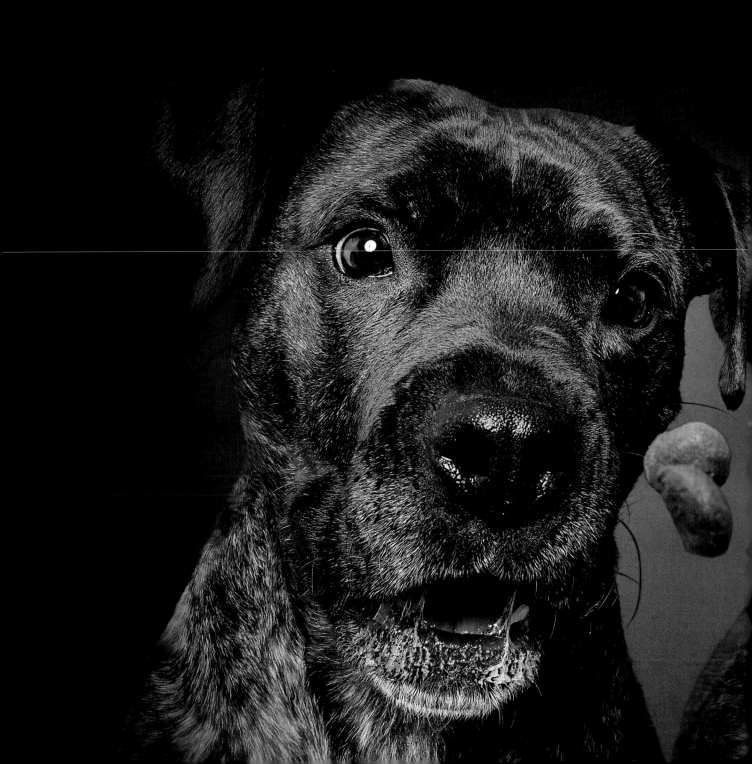

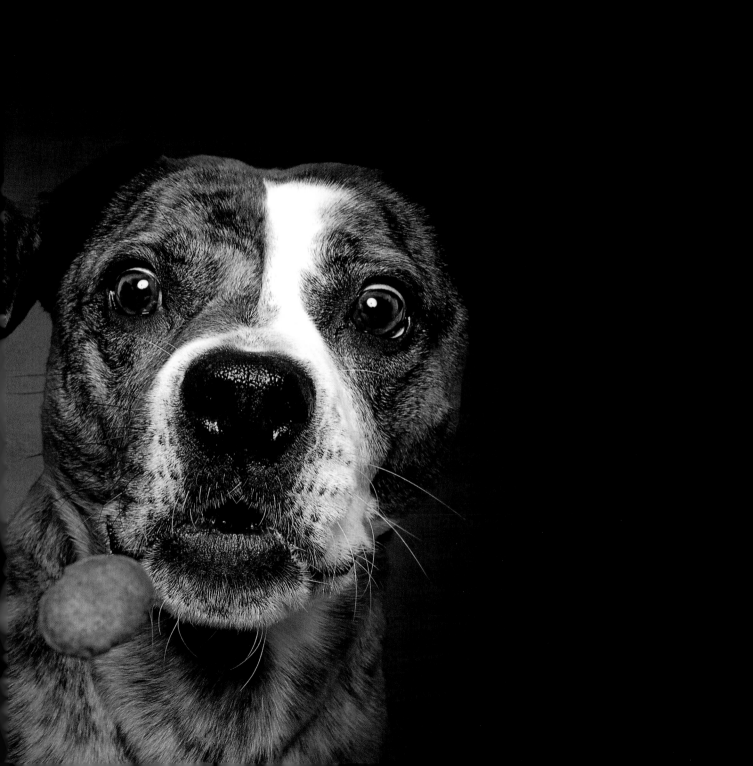

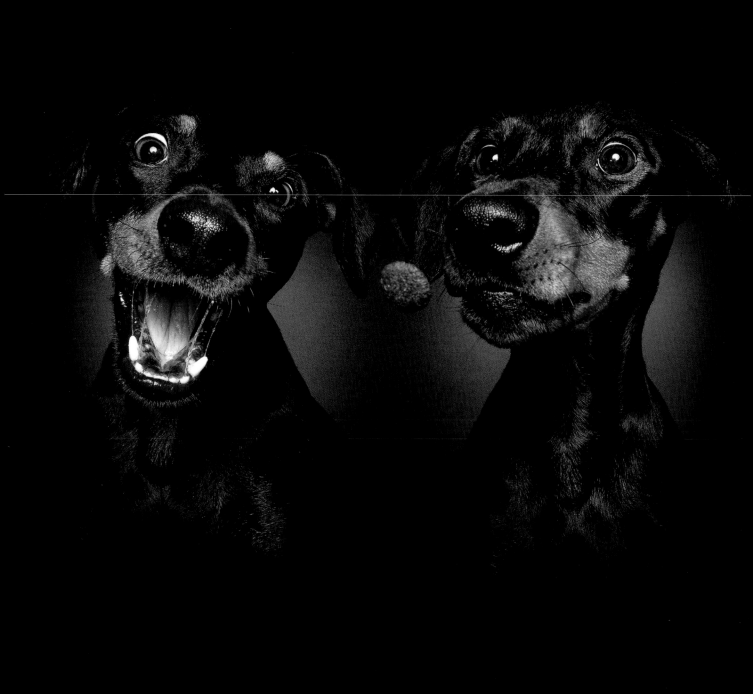

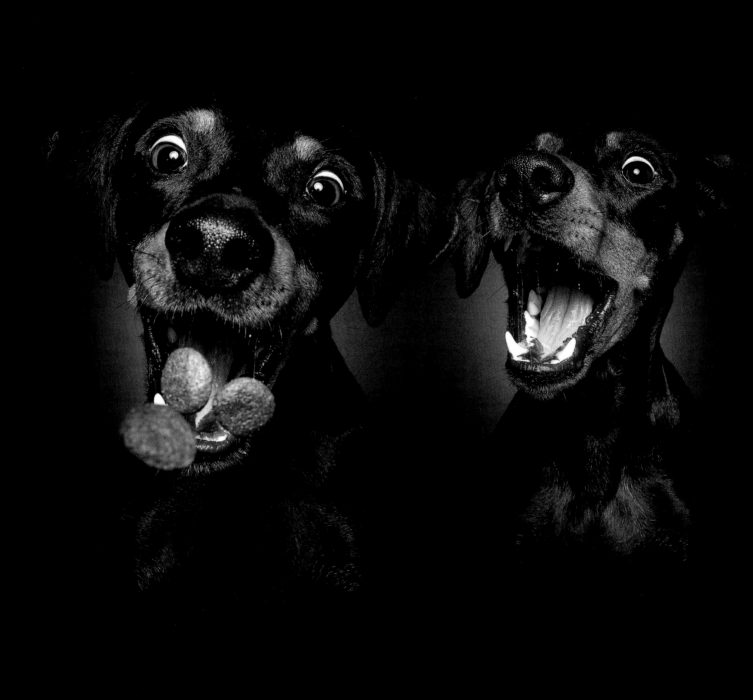

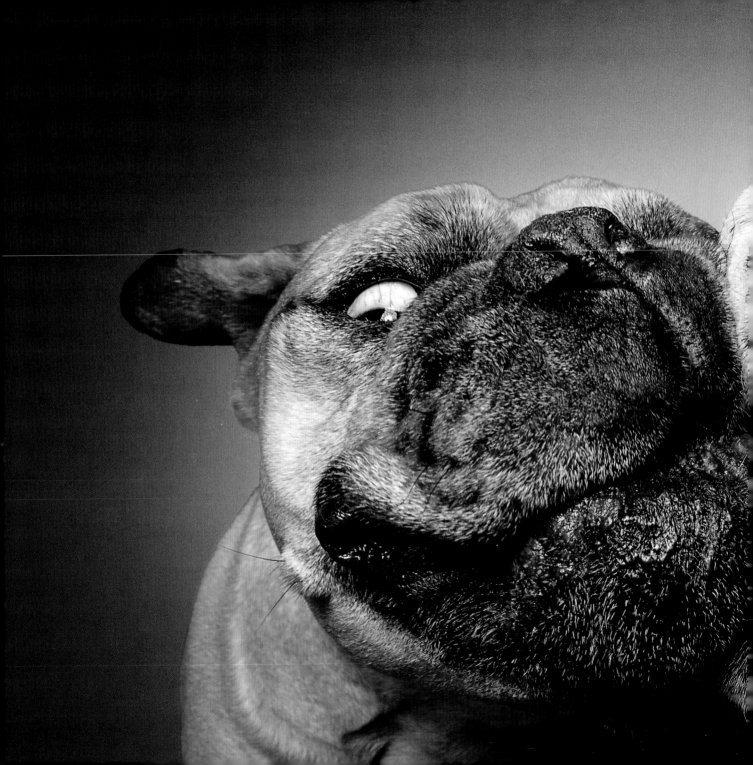

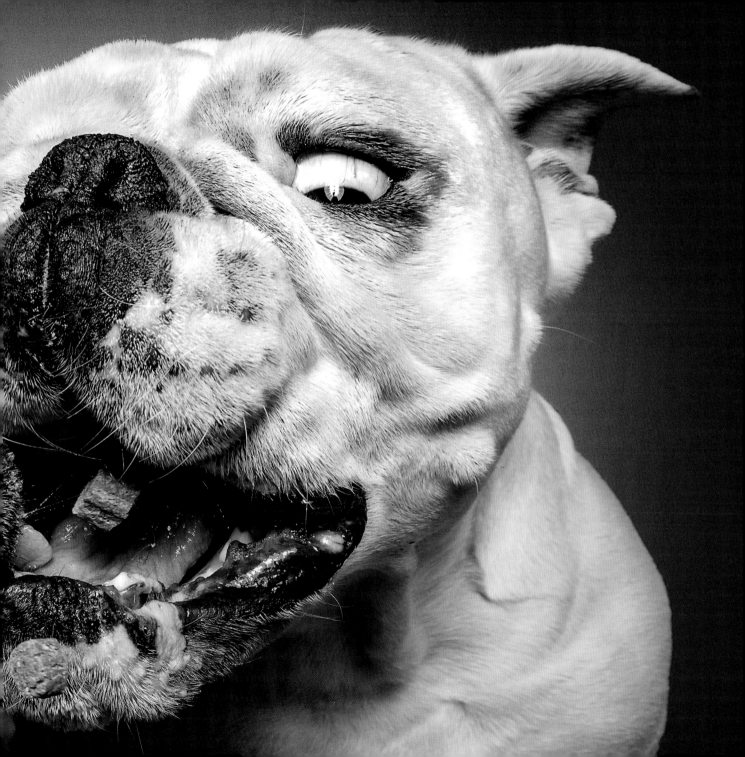

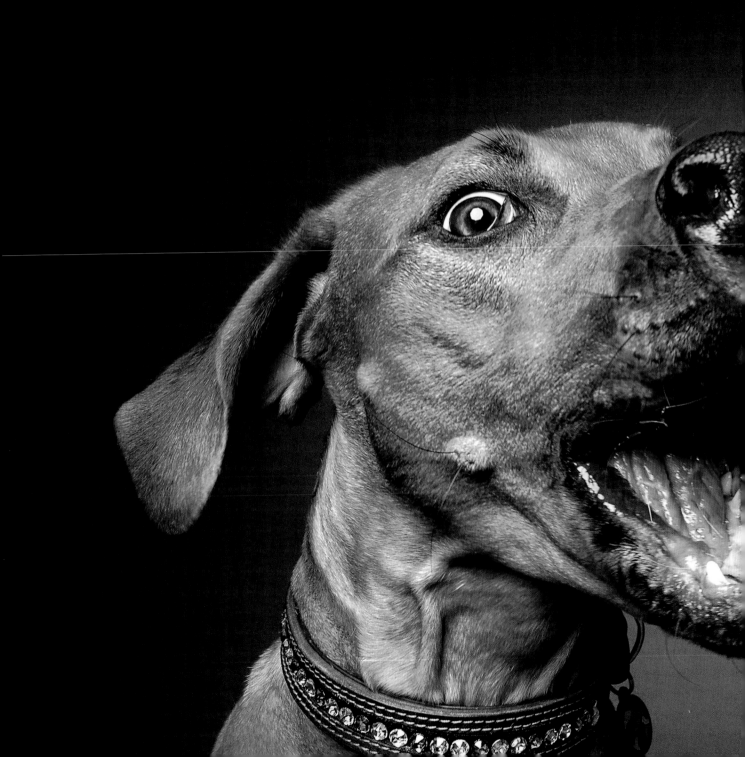

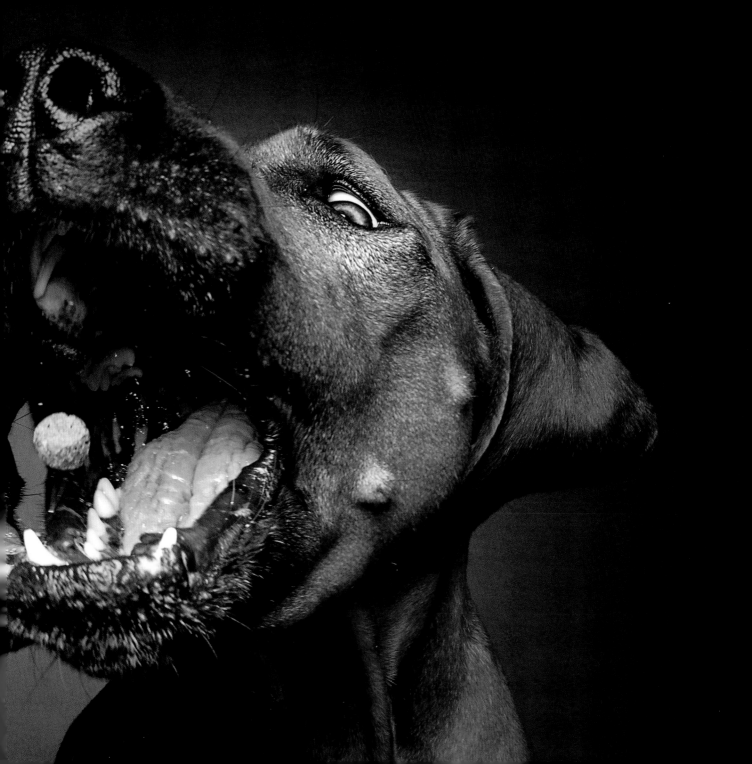

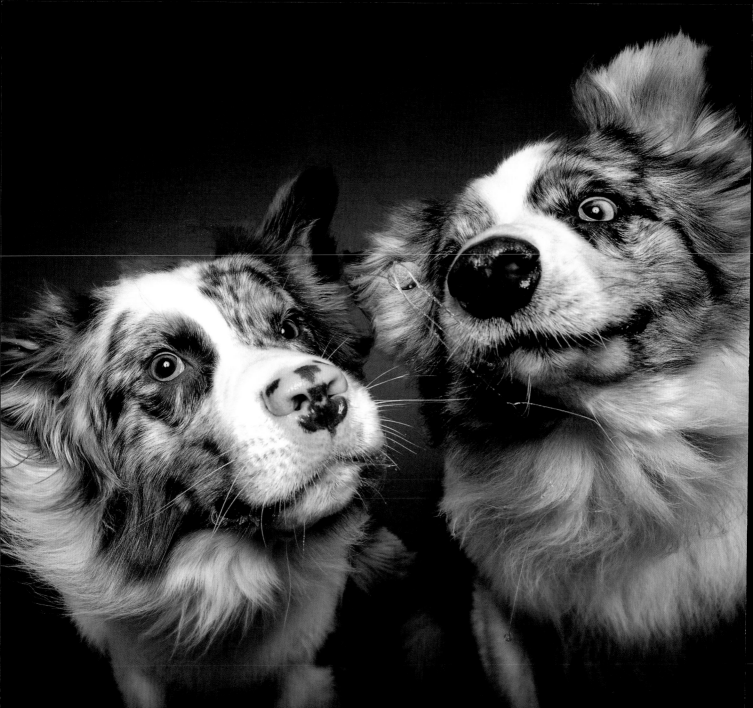

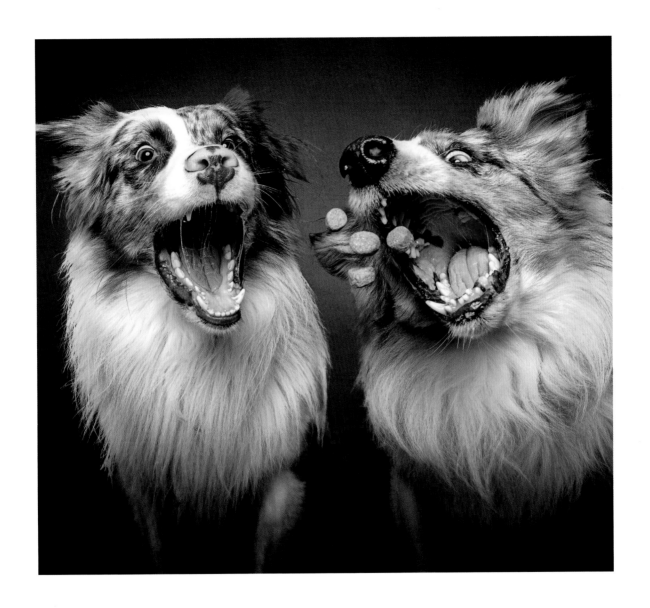

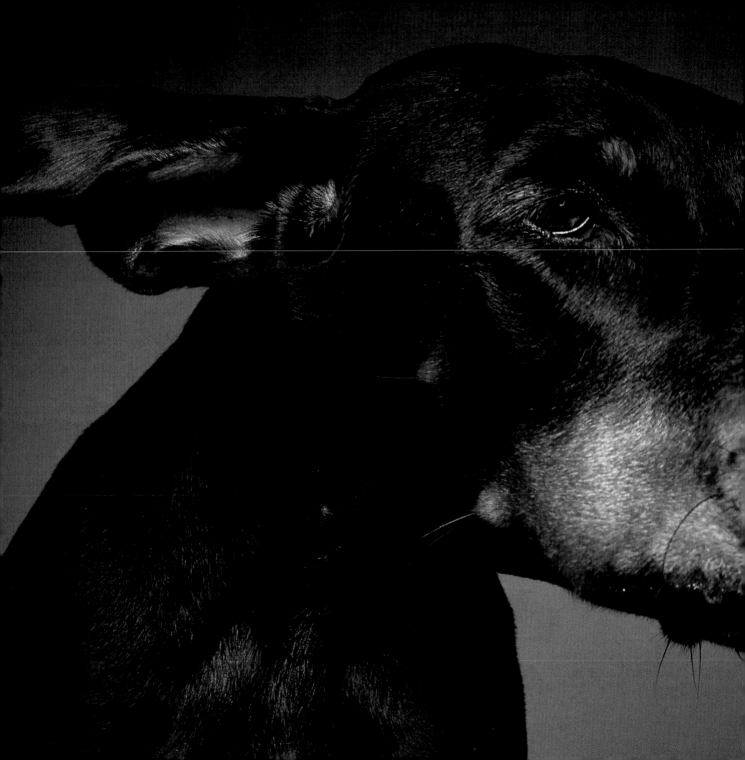

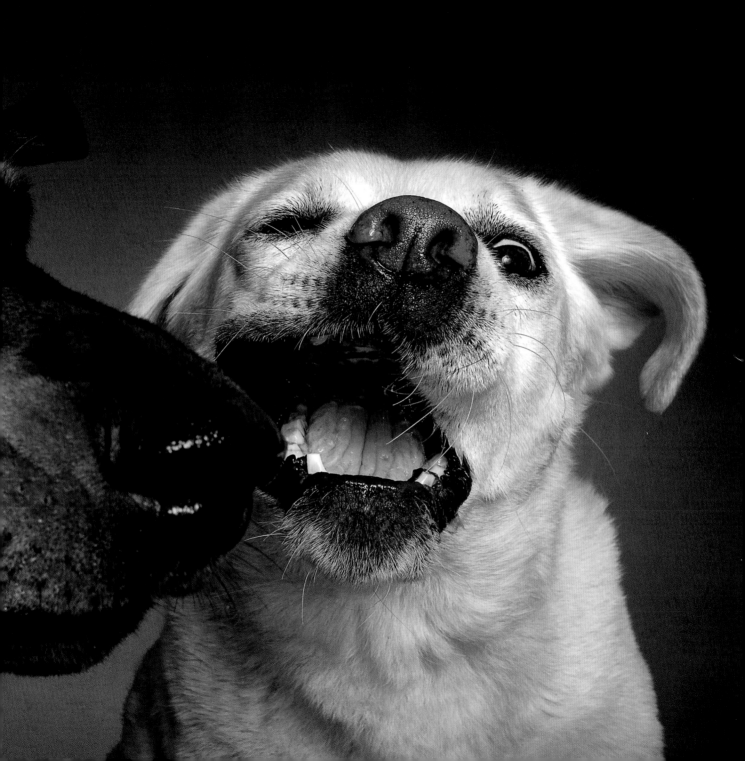

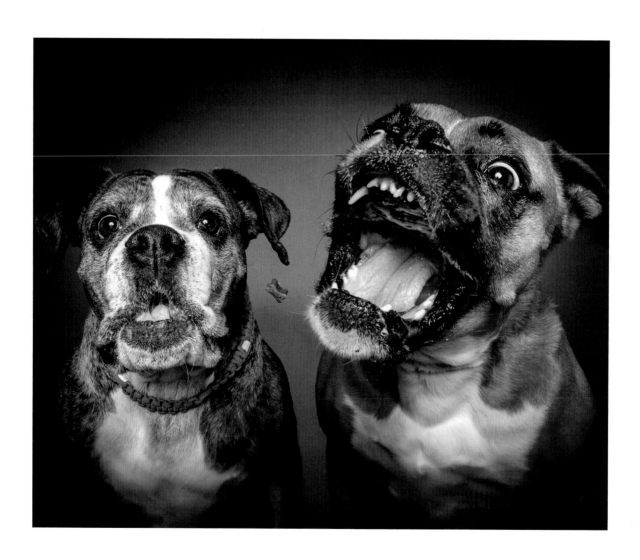

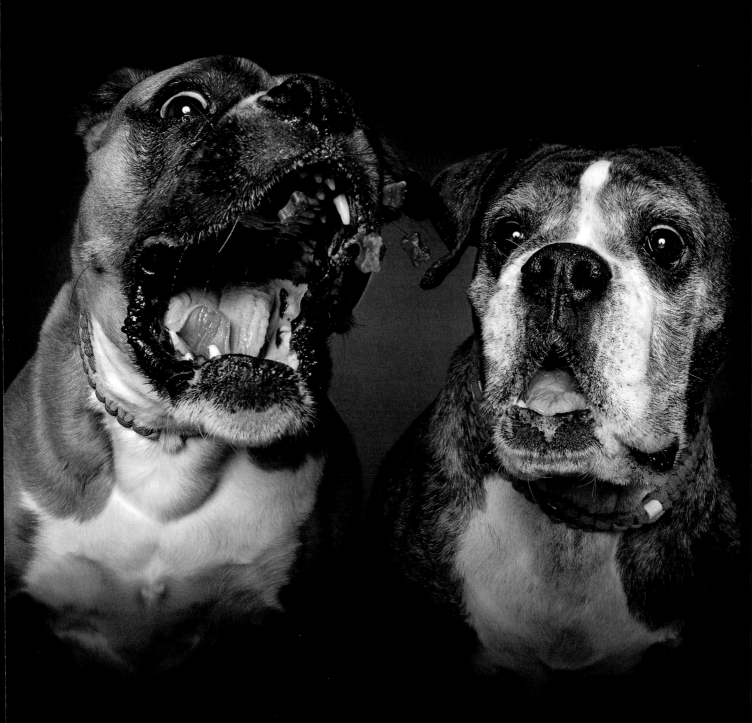

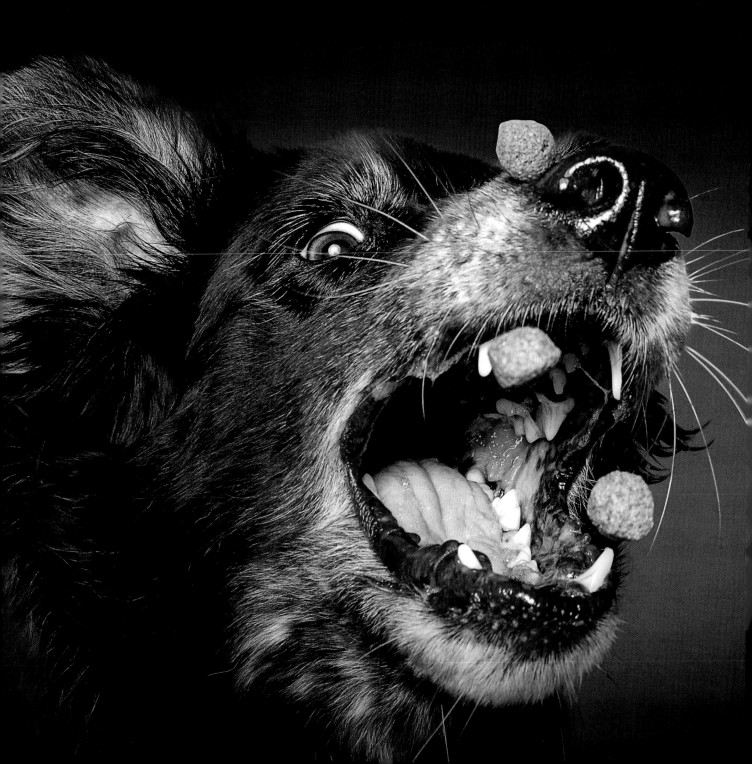

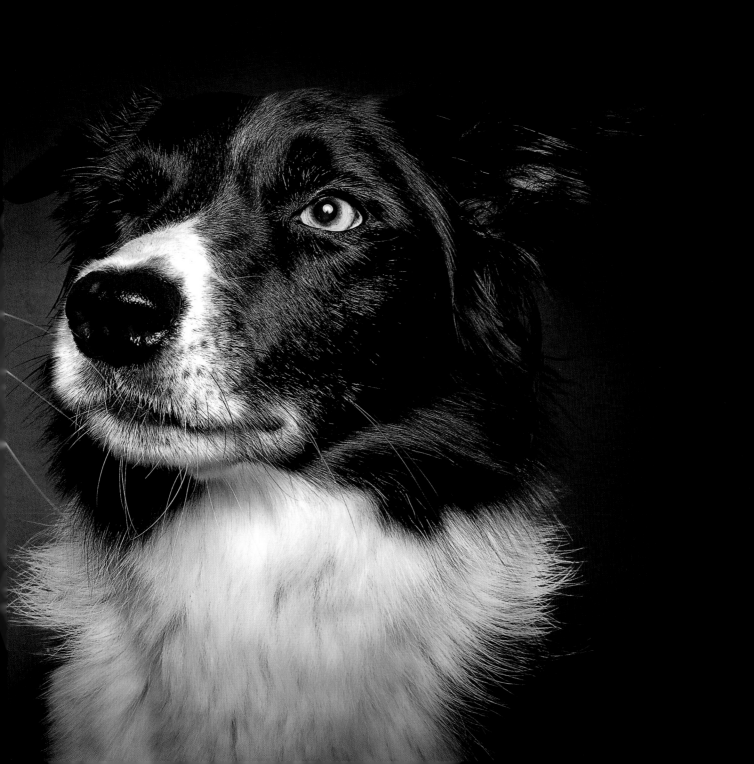

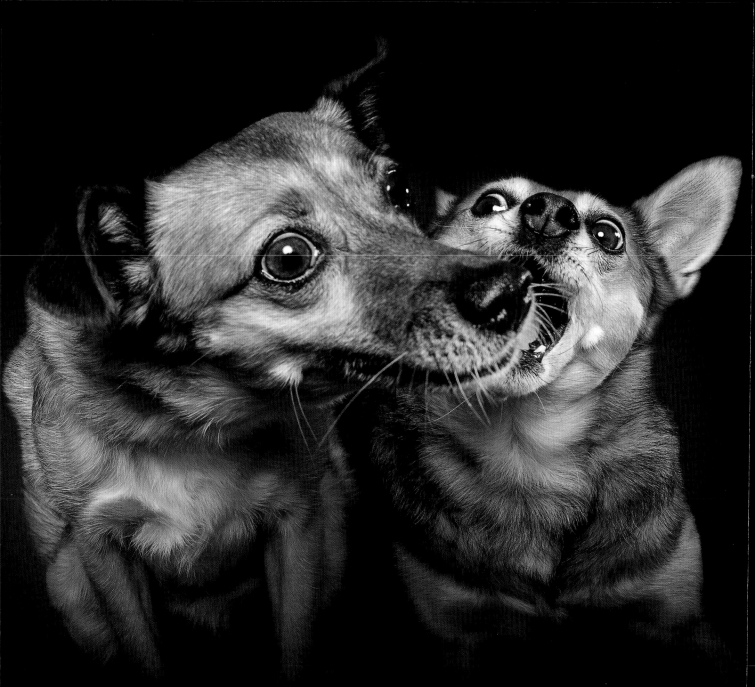

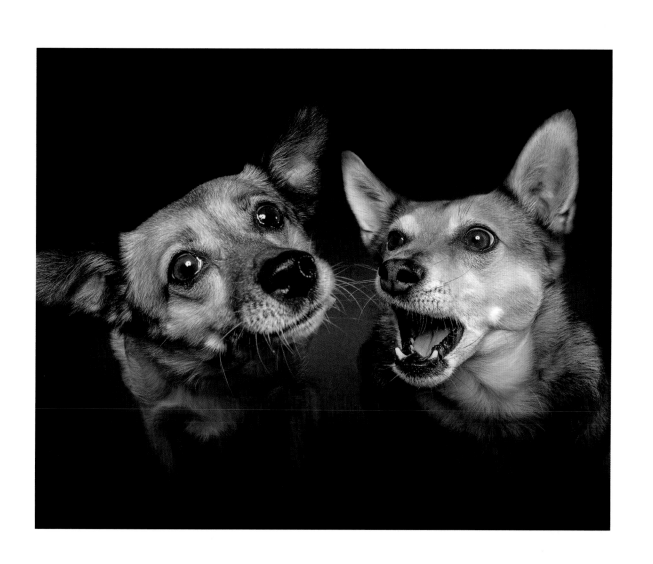

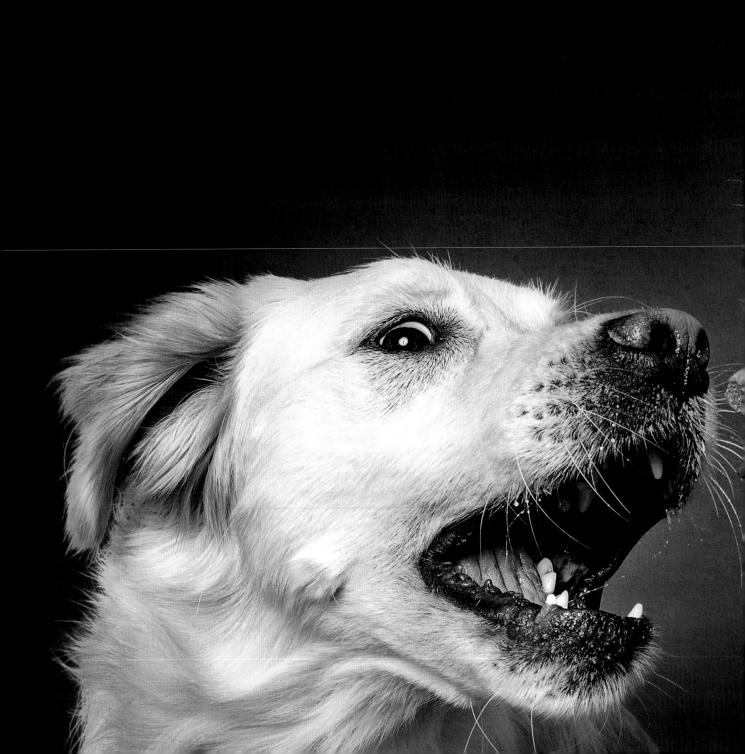

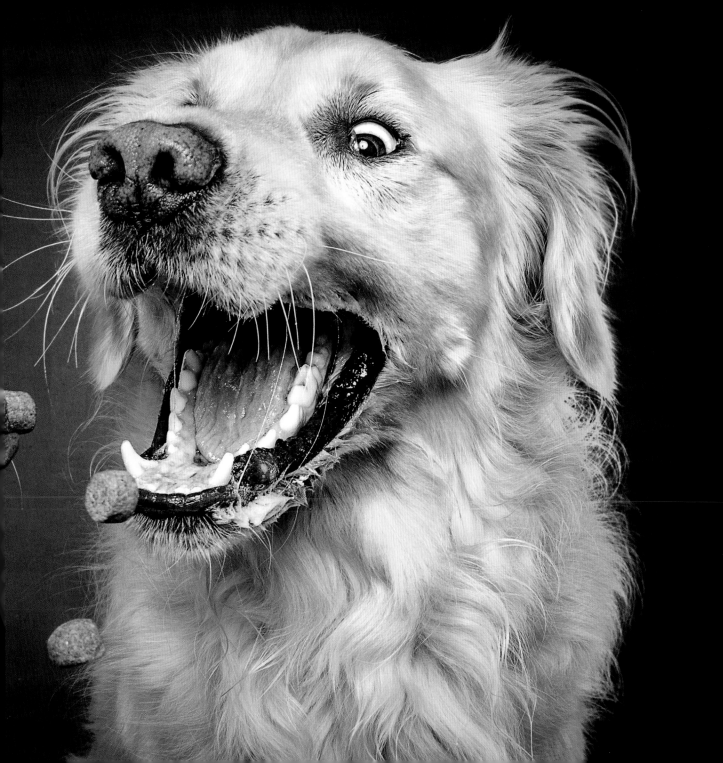

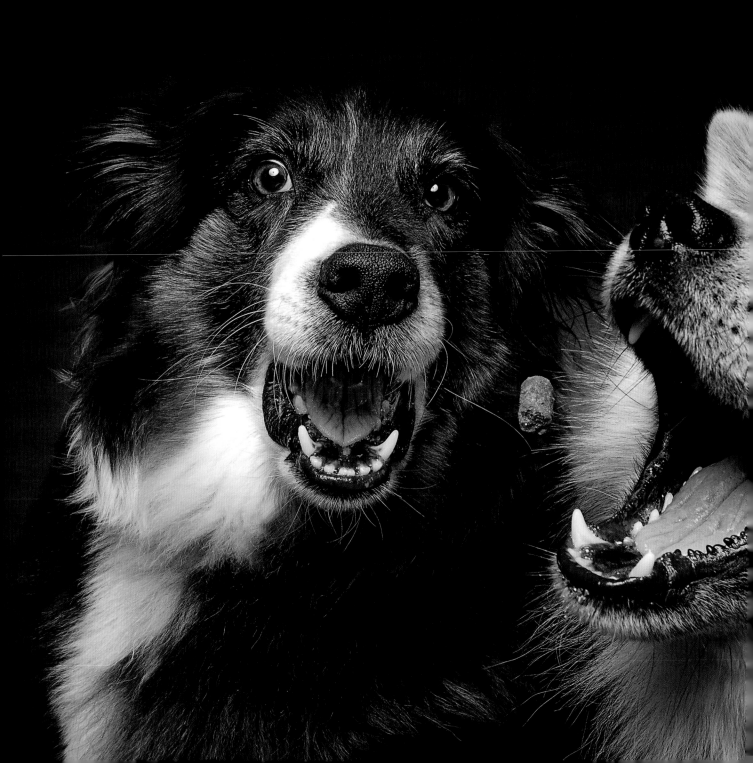

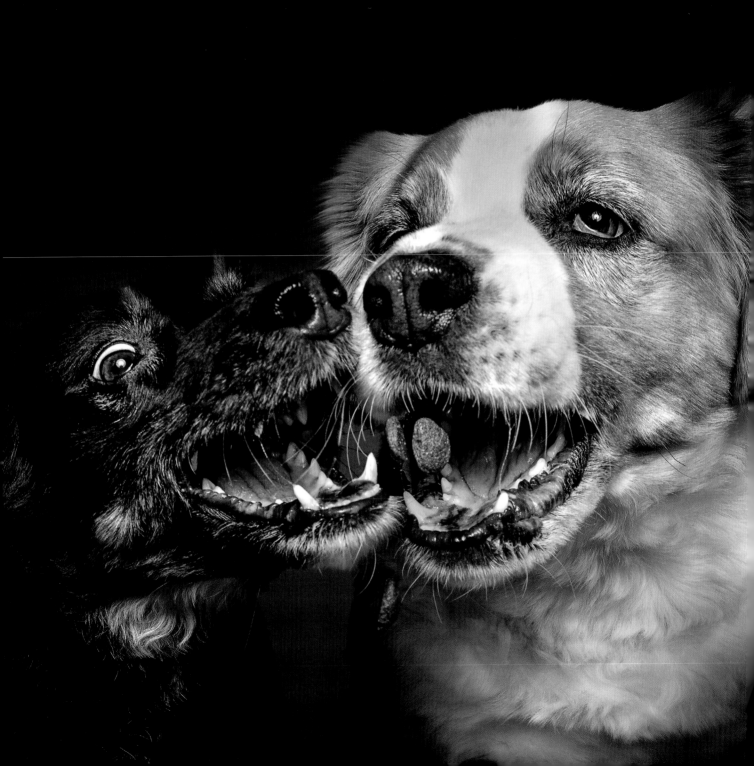

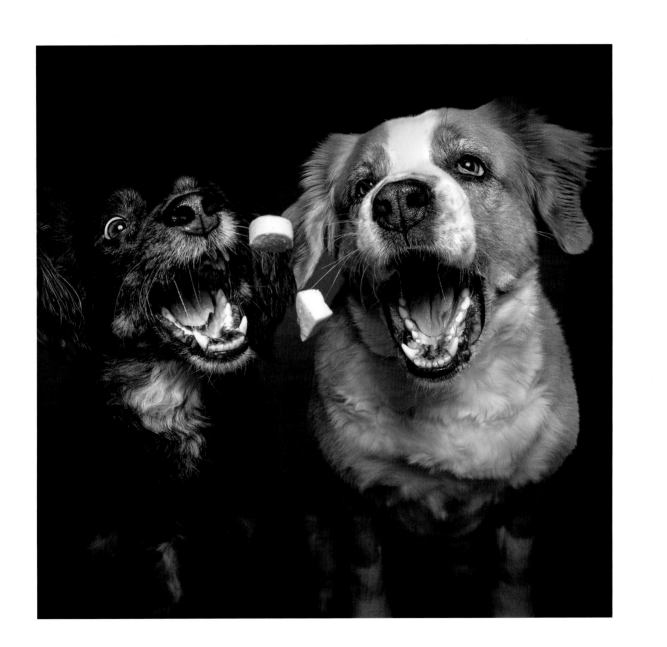

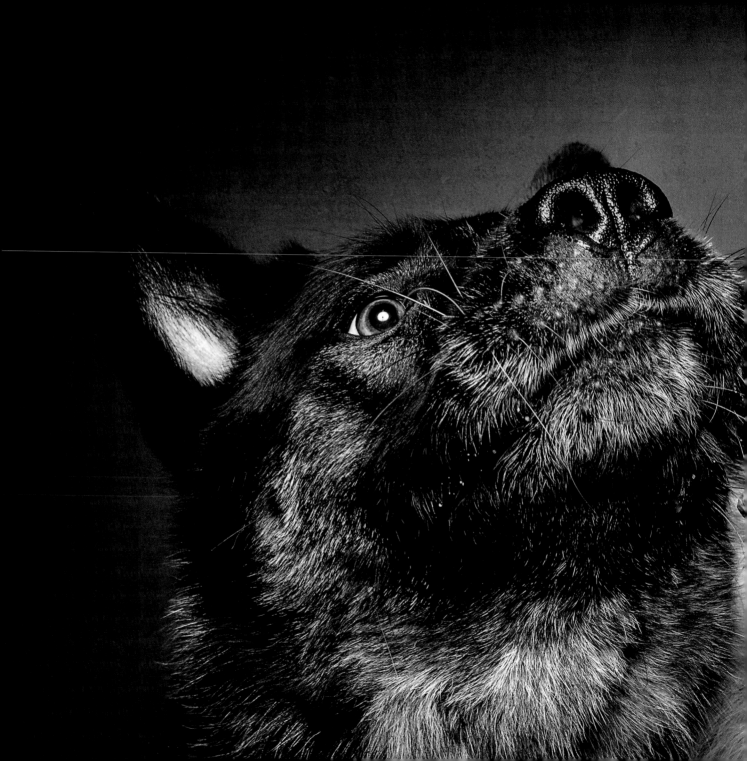

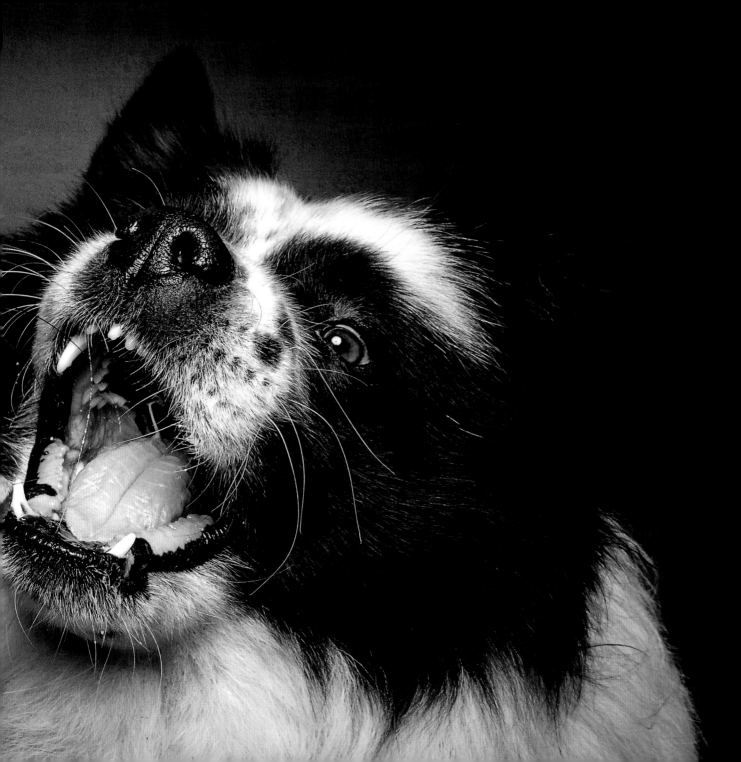

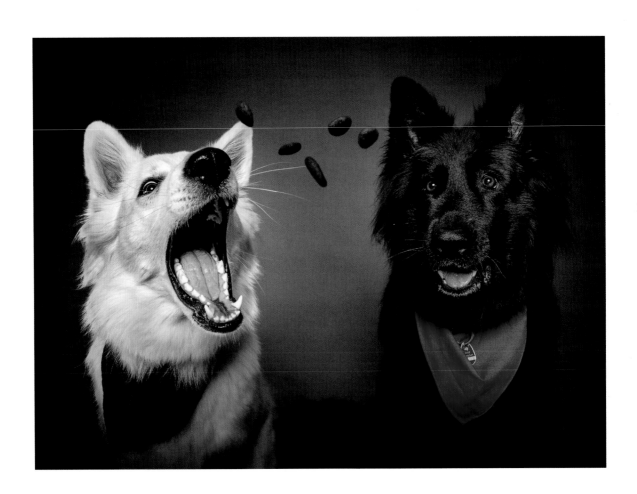

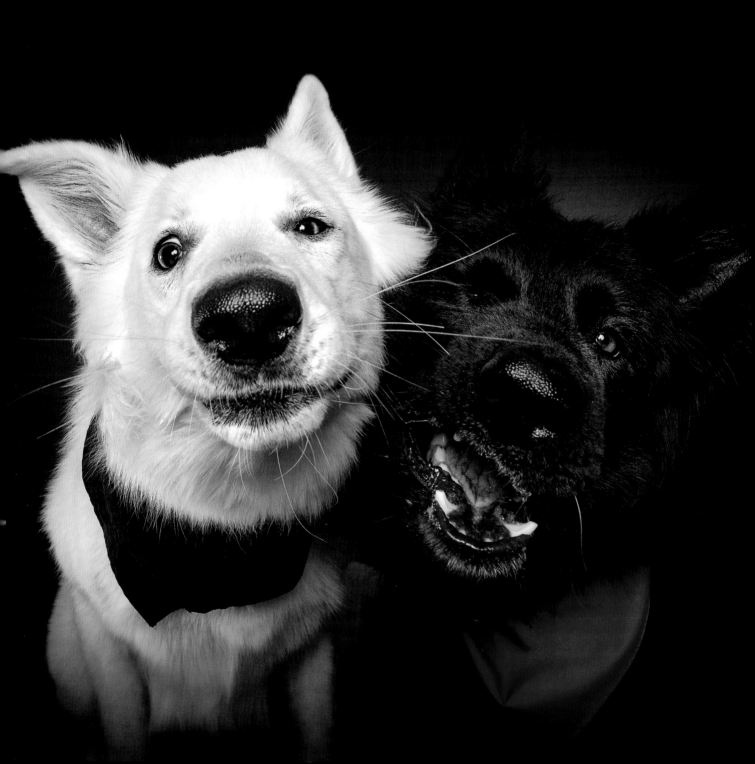

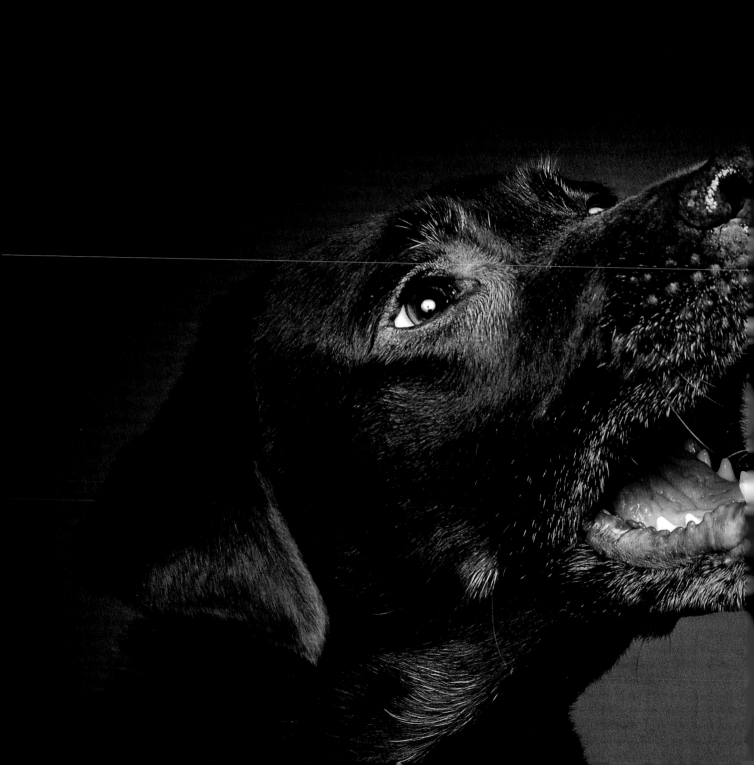

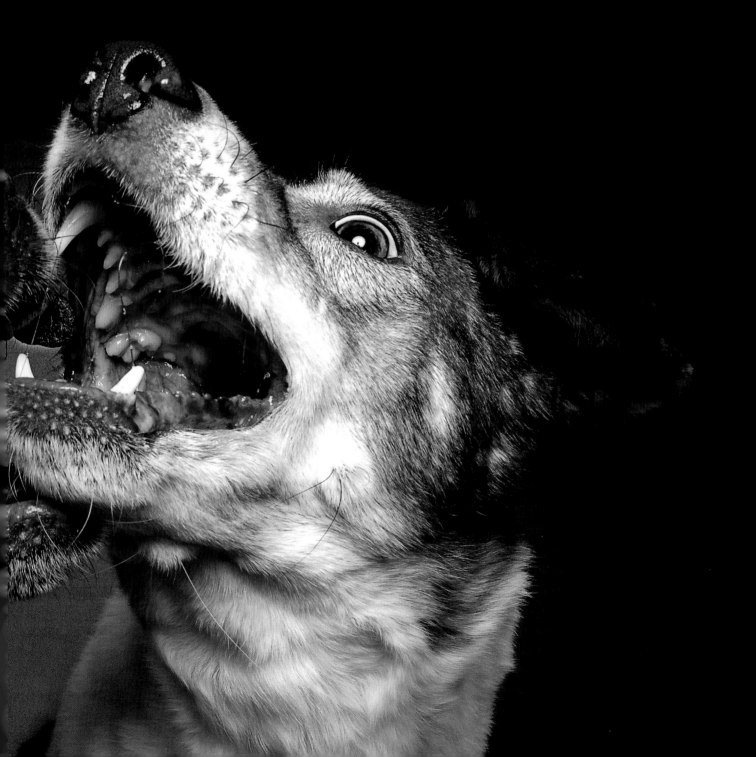

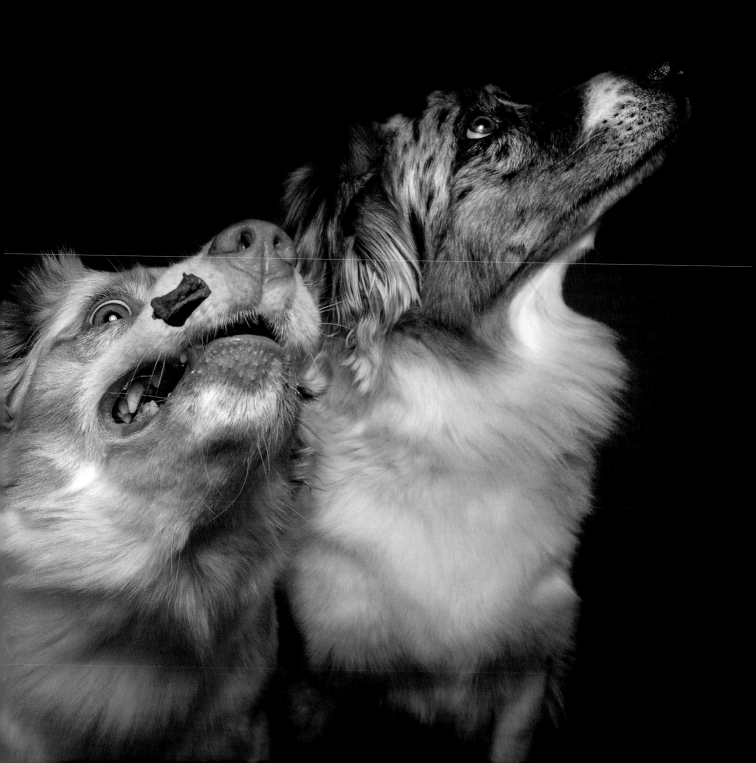

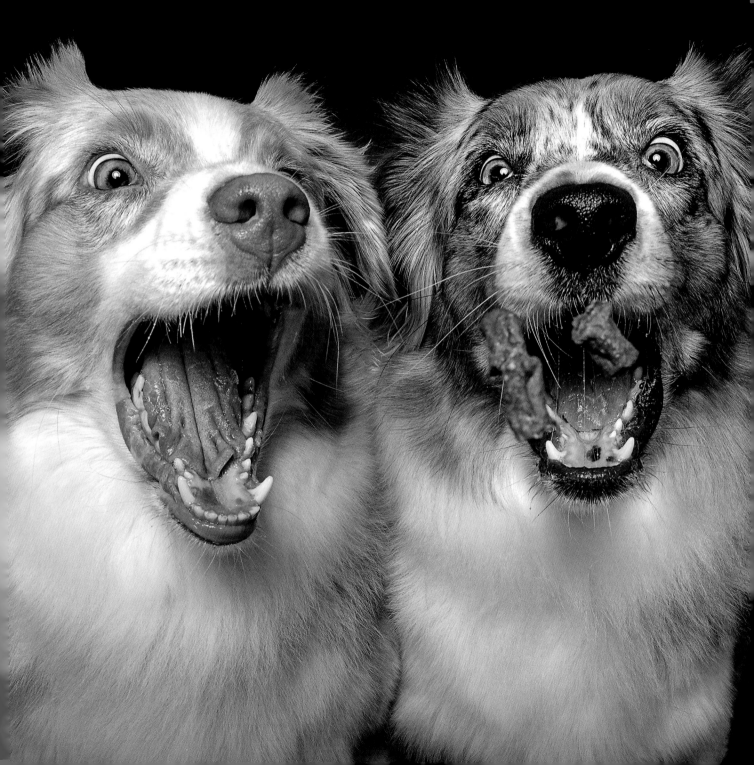

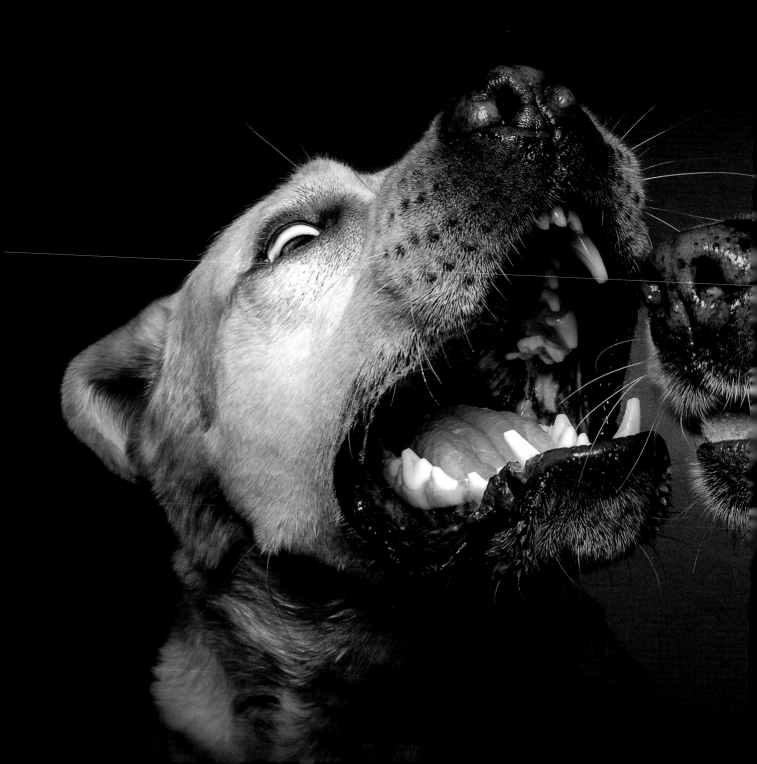

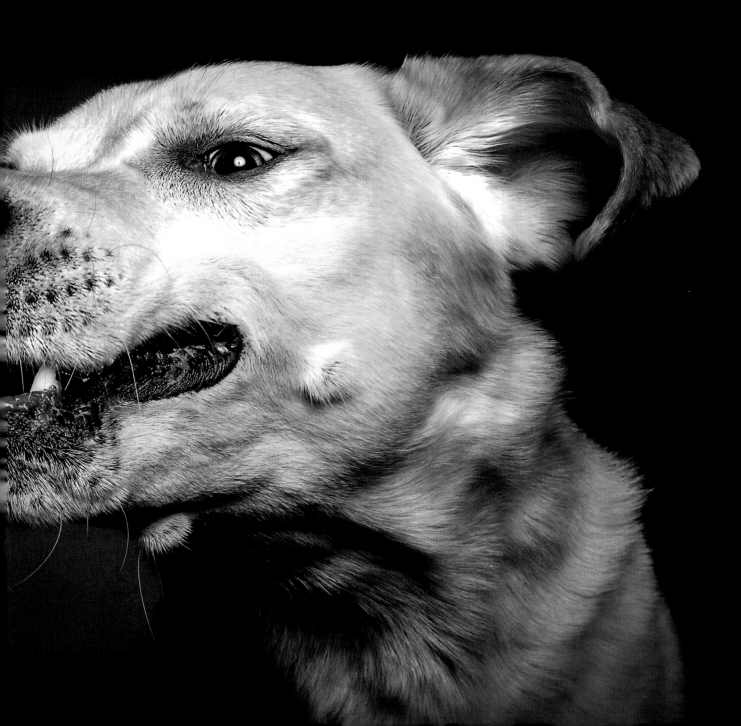

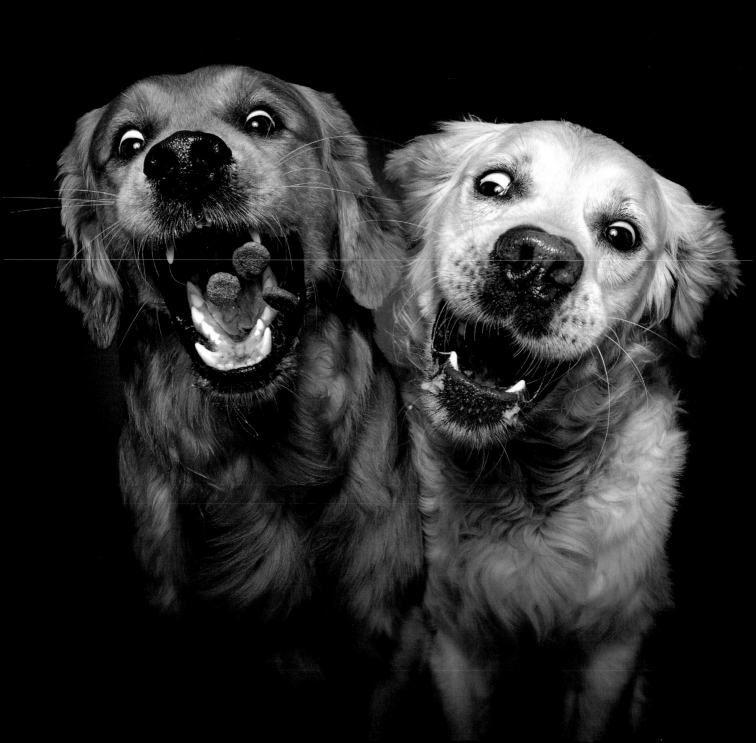

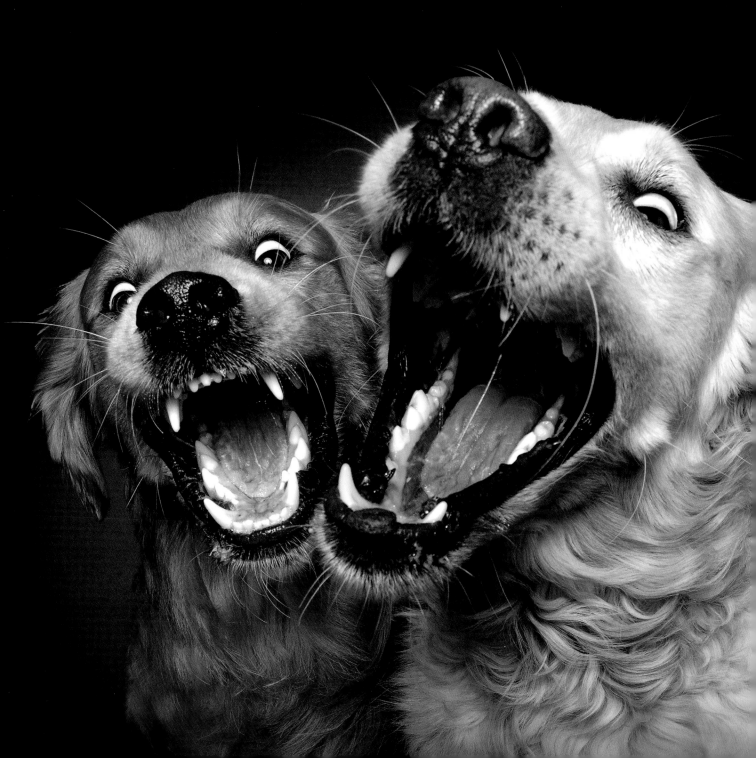

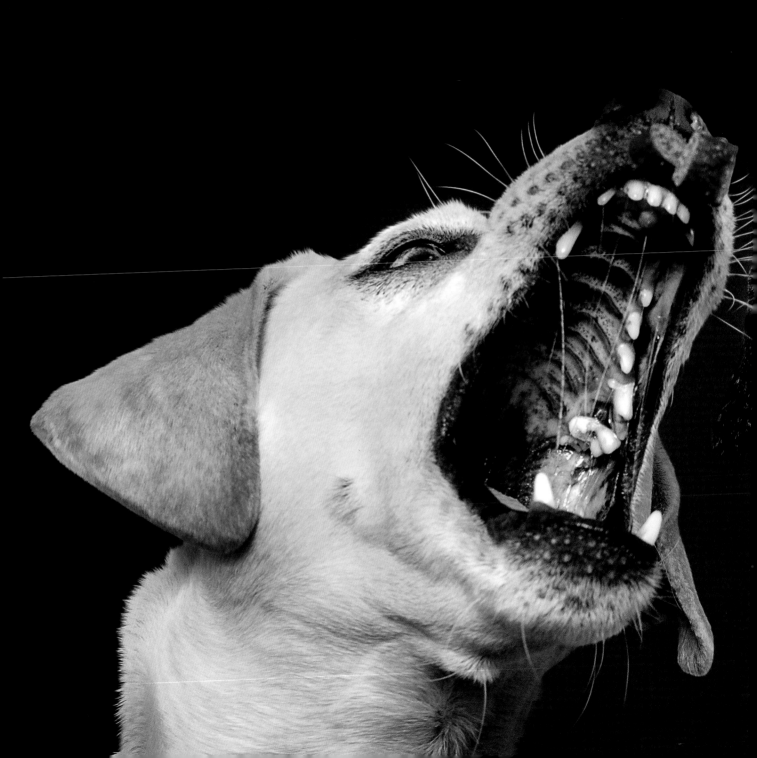

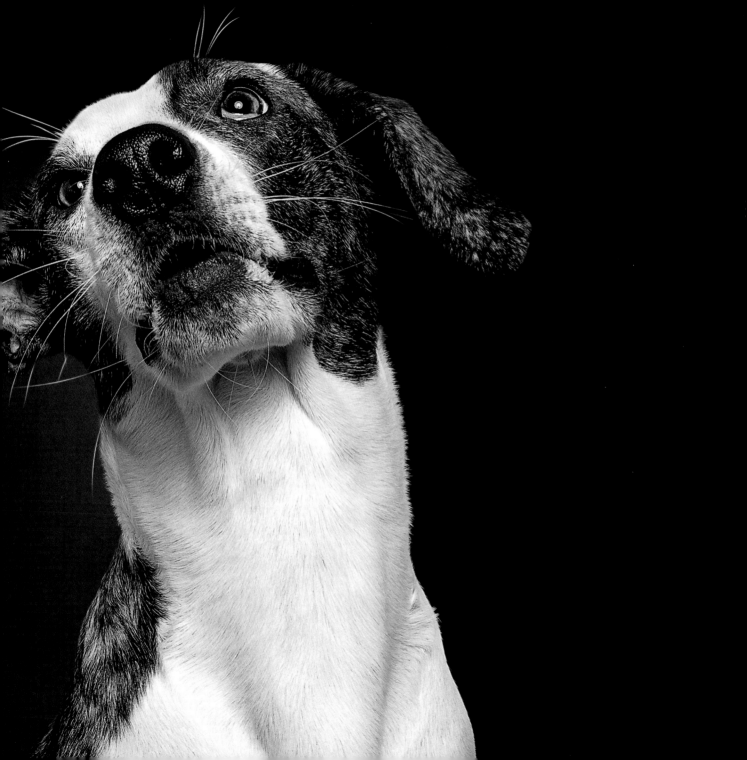

DOG INDEX

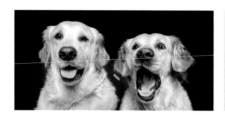

Lilly and Chicko, Labradors

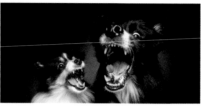

Nala and Kurt, long-haired
Chihuahua and Border collie

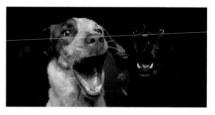

Louie and Lila,
Brittany spaniel and Labrador

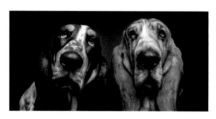

Debbie and Quincy, basset hounds

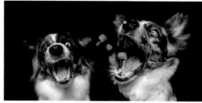

Pebbles and Ninchi,
mini Australian shepherds

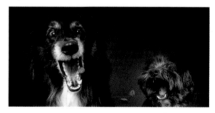

Balou and Pepe, Border collie mix
and mixed breed

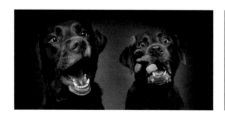

Nele and Amy, Labradors

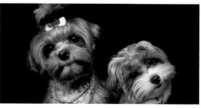

Lotta and Laila, Havaneses

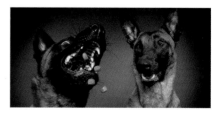

Lennox and Skyy, Malinois

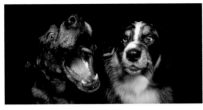

Dushi and Pepper, Labrador–Australian shepherd mix and Australian shepherd

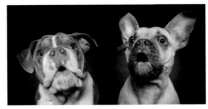

Nika and Milo, French bulldogs

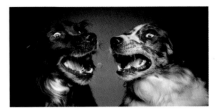

Damian and Lilly, Australian shepherd–golden retriever mixes

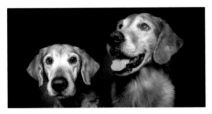

Fila and Riva, golden retrievers

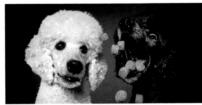

Fibi and Tara, poodles

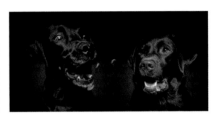

Selma and Marla, mixed breed and Labrador

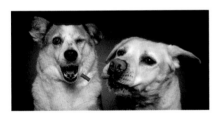

Tamml and Lotte, mixed breed and Labrador

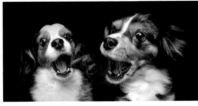

Milo and Melly, Australian shepherds

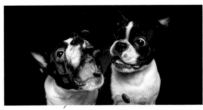

Sookie and Smilla, Boston terriers

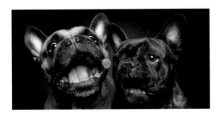

Bazula and Bella, French bulldogs

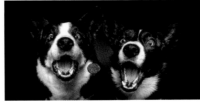

Hilda and Hedwig, Cardigan Welsh corgis

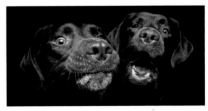

Nele and Amy, Labradors

Ben and Louis, vizslas

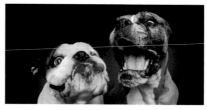

Boyka and Dea, cane corsos

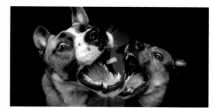

Barney and Floyd, mixed breeds

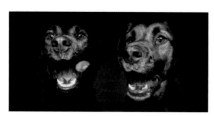

Moritz and Aika, Border collie
and Australian shepherd mix

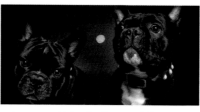

Bella and Emma, boxers

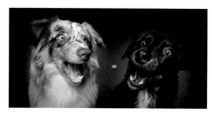

Ben and Lilly, golden retrievers

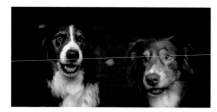

A'Sita and Nero, Malinois and Doberman

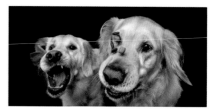

Anton and Manfred, French bulldogs

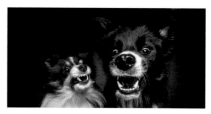

Amy and Ole, Border collie mix
and Australian shepherd

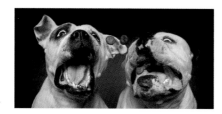

Tenya and Mr. Crumble,
American bulldogs

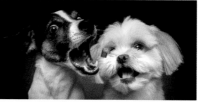

Fiete and Pandora,
Jack Russell terrier and bichon

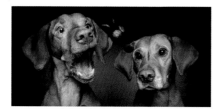

Nala and Kurt, Long-haired Chihuahua
and Border collie

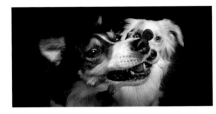

Amy and Rose,
toy fox terrier and Border collie

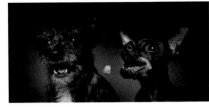

Pitt and Nale, toy terrier and Chihuahua

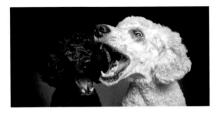

Lola and Lilly, poodles

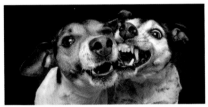

Addi and Hupe, Jack Russell terriers

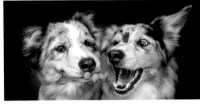

Liese and Lotte, Australian shepherds

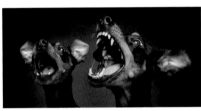

Mila and Lee, miniature pinschers

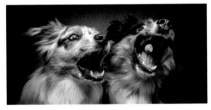

Mila and Milo, Australian shepherds

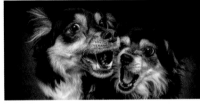

Pia and Mila, mixed breeds

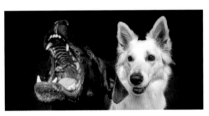

Frieda and Bailey,
Labrador and white Swiss shepherd

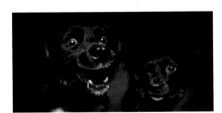

Suki and Suko,
Border collie mix and Spitz mix

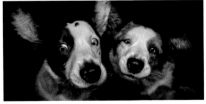

Qullny and Rosie, Cardigan Welsh corgis

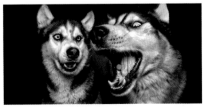

Kuma and Danu, Alaskan malamute
and Siberian husky

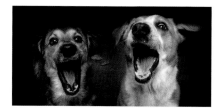

Diego and Jette, mixed breeds

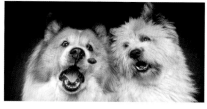

Alice and Elo, Akita–Chow mix
and West Highland terrier

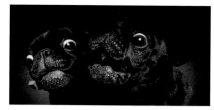

Filou and Hugo, pugs

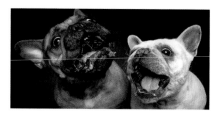

Nika and Mylo, French bulldogs

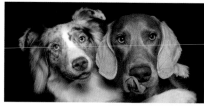

Amy and Ayu, Australian shepherd
and Weimaraner

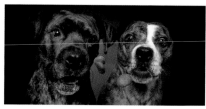

Anni and George, boxer–pit bull mix
and French bulldog

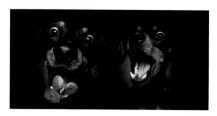

Mila and Lee, miniature pinschers

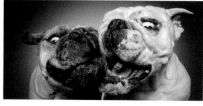

Schorsch and Soey, American bulldogs

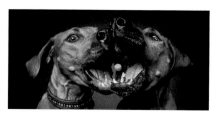

Donna and Frida, Rhodesian ridgebacks

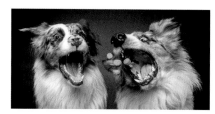

Honey and Maya, Australian shepherds

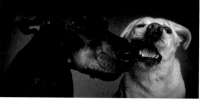

Anni and Lotte,
Doberman and Labrador

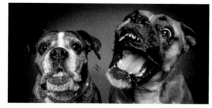

Lina and Karlo, boxers

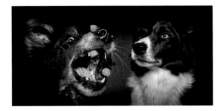

Chuna and Mojo, mixed breeds

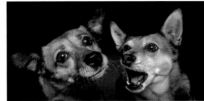

Didi and Maja, mixed breeds

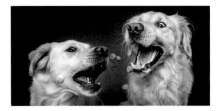

Ben and Lilly, golden retrievers

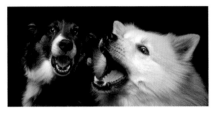

Vinur and Glenn, Icelandic sheepdog
and Border collie–Australian shepherd mix

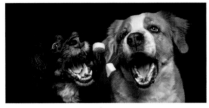

Janosch and Leika, mixed breeds
Marty McFly and Nikita vom Schwarzen

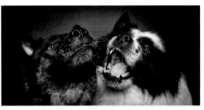

See, Elo-cattle dog mix and Elo

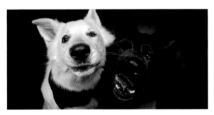

Sally and Flocke, white Swiss shepherd
and German shepherd

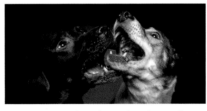

Lotte and Laska, Labrador and
mixed breed

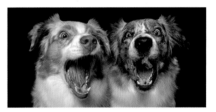

Honey and Maya, Australian shepherds

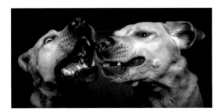

Anton and Mino, golden retrievers

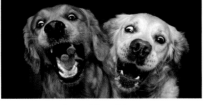

James and Nedd, golden retrievers

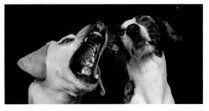

Findus and Sweety, mixed breeds

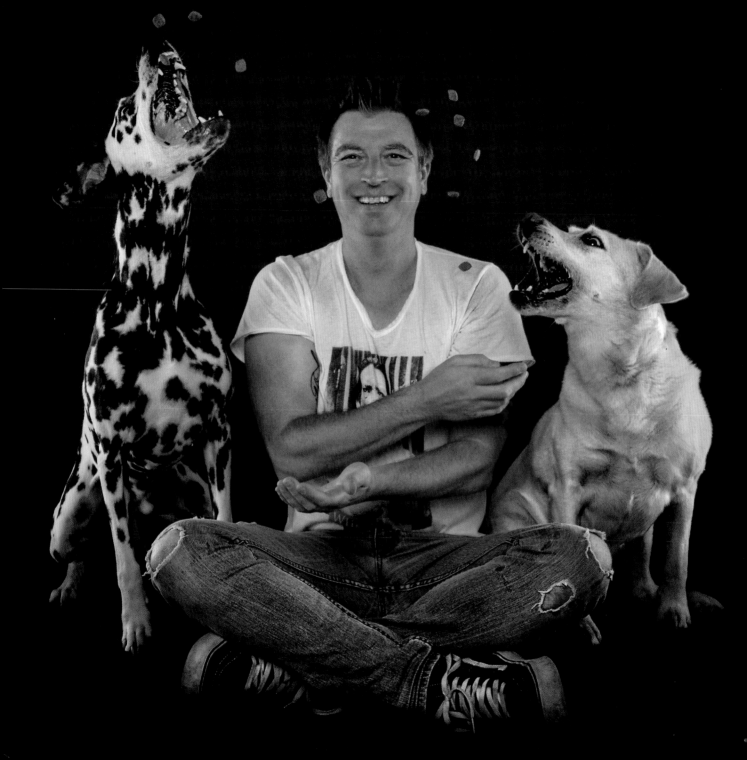